THE ART & DESIGN SERIES

For beginners, students, and working professionals in both fine and commercial arts, these books offer practical how-to introductions to a variety of areas in contemporary art and design.

Each illustrated volume is written by a working artist, a specialist in his or her field, and each concentrates on an individual area—from advertising layout or printmaking to interior design, painting, and cartooning, among others. Each contains information that artists will find useful in the studio, in the classroom, and in the marketplace.

BOOKS IN THE SERIES:

Thomas Griffith, a professor of art at California State University, Chico, has had more than 25 years' experience teaching undergraduates and graduates.

A practical guide for

BEGINNING

THOMAS GRIFFITH

PAINTERS

WITHDRAWN

A SPECTRUM BOOK PRENTICE-HALL, INC., Englewood Cliffs, New Jersey 07632

Library of Congress Cataloging in Publication Data

GRIFFITH, THOMAS (date).
 A practical guide for beginning painters.

 (The Art & design series) (A Spectrum Book)
 Bibliography: p.
 Includes index.
 1. Painting—Technique. I. Title. II. Series:
Art & design series.
ND1500.G68 750'.28 80-18108
ISBN 0-13-689513-1
ISBN 0-13-689505-0 (pbk.)

*For Brenda, Madeleine, and Robert,
and my children, Robin, Willo, and Kathryn*

THE ART & DESIGN SERIES.

Cover illustration:
CHRIS FORREST
Egret (oil).
Courtesy of Chris Forrest Wildlife Studio.

A Practical Guide for Beginning Painters, by Thomas Griffith.
© 1981 by Prentice-Hall, Inc., Englewood Cliffs, New Jersey 07632.
All rights reserved. No part of this book may be reproduced in any
form or by any means without permission in writing from the publisher.
A Spectrum Book. Printed in the United States of America.

10 9 8 7 6 5 4 3 2 1

Editorial/production supervision
by Suse L. Cioffi and Eric Newman
Page layout by Mary Greey
Manufacturing buyer: Cathie Lenard

PRENTICE-HALL INTERNATIONAL, INC., *London*
PRENTICE-HALL OF AUSTRALIA PTY. LIMITED, *Sydney*
PRENTICE-HALL OF CANADA, LTD., *Toronto*
PRENTICE-HALL OF INDIA PRIVATE LIMITED, *New Delhi*
PRENTICE-HALL OF JAPAN, INC., *Tokyo*
PRENTICE-HALL OF SOUTHEAST ASIA PTE. LTD., *Singapore*
WHITEHALL BOOKS LIMITED, *Wellington, New Zealand*

Contents

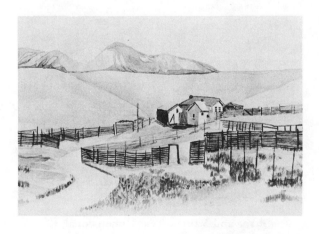

Preface

What makes an art work good or bad? How can we define "talent"? These are questions that frequently come up with artists or non-artists alike. And although they are valid questions, they are difficult to answer. The one reply I can give is that all of us have the potential to work creatively in one way or another. One student may have a particular strength in drawing, whereas the next person may be a gifted colorist. Also, the various painting media available to us need to be ex-plored. The rich qualities of oil pigments may be exciting to you at one time, whereas the delicate intermingling of watercolors may captivate you at another.

Rather than presenting complex theo-ries in this book, I have taken the approach of giving you down-to-earth information: for example, which pigments have the greatest versatility, and a chart of their trade names as they are identified in the art stores. My at-tempt has been to provide you with a straight-

forward manual, regardless of whether you are enrolled in a painting class or not.

For these reasons I have tried to keep the text of *A Practical Guide for Beginning Painters* broad in scope, while dealing with basic fundamentals. I hope this book will provide a proper response to the beginning painter's query: "Could you recommend something I could read that would help me get started with painting?"

I am very grateful for the fine black-and-white photography by Anne Ficarra and Michael Simmons, the diagrams by Gary Goundrey, and the accurate color work by Fleet Irvine. To those students and fellow artists who gave their time to assist in this endeavor I also wish to give my thanks. Without their help this book would not exist.

My special thanks go to my wife, Brenda, for the hours of typing and patient help with verbalizing many of the concepts that for the artist often go unsaid; to Michael Simmons for his creative energy in the interpretation of visual material; and finally, my thanks go to my friend and editor Mary Kennan, as well as to my able production editors, Suse Cioffi and Eric Newman.

A practical guide for

BEGINNING PAINTERS

I WOULD LOVE TO PAINT, but I just don't have the talent. I don't know where to begin." How often those feelings are expressed. As children of six or seven we plunged headlong into the world of art, splashing paint in every direction and thoroughly enjoying ourselves. But then, in later years, the inhibitions brought on by criticism and division of interests eroded confidence in self-expression. The ability to reveal self without fear became lost, and now we search for a renewal of creative energy.

So—how do we pick up where we left off as children? No longer are we satisfied with the sheer pleasure of pushing paint around. We need new skills, and we need them with a minimum of frustration.

The beginning painter should be equipped with some fundamental "tools of expression" that will lead to successful expe-

Introduction

riences. Theories divorced from the real world or overgeneralized information can be confusing rather than helpful. The purpose of this book is to provide the kind of practical information that achieves realistic goals.

There are two paths to be dovetailed in progress toward a really satisfying love of the act of painting (see Figure 1.2).

Since later chapters in this book are concerned with fundamentals of picture mak-

ing, let us begin by setting the wheels of creativity in motion. Renoir taught us the power of the creative process: When old and crippled, he painted with the brushes strapped onto his wrists. It is important to realize at the outset that you are not alone in either the desire for self-expression or in your fears of falling short in its implementation. Those first marks you make are the hardest, but it is through "doing" that confidence grows.

Figure 1.1
ANNE FICARRA
Elise (photograph).
Courtesy of the photographer.

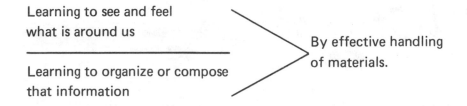

Learning to see and feel
what is around us

Learning to organize or compose
that information

By effective handling
of materials.

Figure 1.2

THE WORLD AROUND US—
learning to see

One of the most gratifying aspects of painting is that through a direct encounter with nature, you will experience a new awareness of the visual world. This develops quite rapidly, so that even beginning students frequently make such remarks as "I had no idea that the textures and patterns of leaves were so varied," or "suddenly I find myself looking at tree trunks to see their actual colors" (see Plate 1). Chapter Five discusses ways not only to see colors, but to mix them as well.

The Sketchbook—A Personal Journal

The sketchbook is a diary of feelings, events, and observations. It is particularly valuable for the beginner since its privacy does not lend itself to criticism. There are three important purposes in keeping such a record:

• It serves as a memory bank for your impressions and observations.

• It is a planning area for future work.

• As skills develop, you will become less self-conscious and more confident.

The vitality of the sketchbook is evident in Plate 2. This postcard-size watercolor, by the nineteenth-century master Delacroix, is one of the many vivid "color notes" he made while traveling in North Africa.

Time to Perceive

The hectic world in which we live does not lend itself to our becoming sensitive to the natural environment unless we make the effort. Examine the tide pool, newly emerging

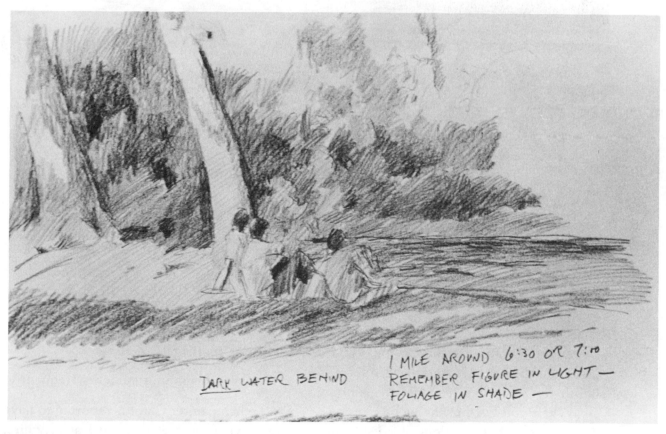

Figure 1.3
WAIF MULLINS
Sketchbook page (charcoal pencil).
Courtesy of the artist.

The artist has noted the time of day and has penciled in reminders of his observations.

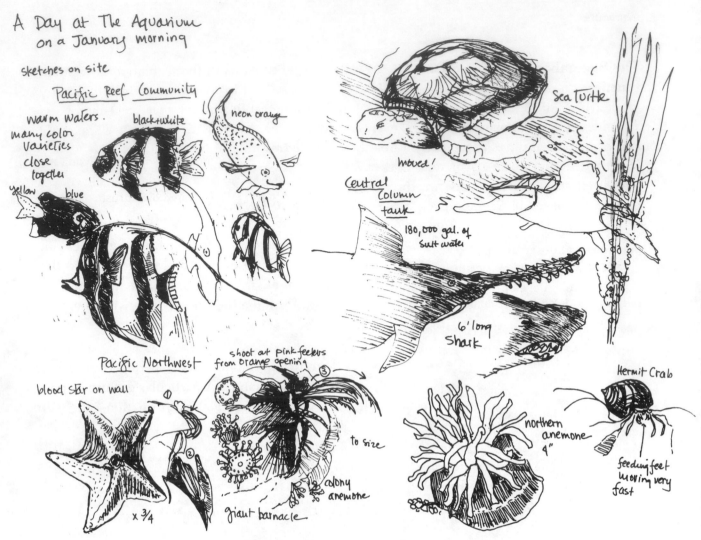

Figure 1.4
CLARE WALKER LESLIE
Sketchbook page from a visit to an aquarium (felt-tip pen).
Courtesy of the artist.

Drawing offers a focus for study and record taking of animals seen at places such as an aquarium.

leaves, the rhythmical order of the pine cone, or even the texture of a charred log. We are surrounded by natural forms that can serve as stimuli for a creative response in painting.

When you walk in the woods, or even on a city street, take along a friend with whom you can share observations. Each one of us has a unique way of seeing, which can enhance the perceptions of others.

THE WORLD WITHIN—the reality of feeling

The French painter Corot is reported to have said, "What we feel is as real as anything else." Developing a capacity for revealing inner emotions is another benefit that can result from becoming involved with the

creative process. A strong educational system not only teaches the three *R*s, but it also reinforces children's ability to express themselves creatively. The reason that many of us are somewhat reluctant to reveal ourselves graphically on the painted surface is that we were not encouraged to do so at the proper time in our development. For those interested in pursuing developmental creative levels, Victor Lowenfeld's *Creative and Mental Growth* is included in the bibliography.

SUGGESTED EXPERIENCES— how to begin

Let's start with a basic kit of materials, which will be added to in subsequent chapters.

- Small fishing-gear box.
- Several colored felt-tip pens (sets are available).

- 1 set of oil pastels.
- 1 5 or 6B pencil.
- 1 2H pencil.
- Single-edged razor blade.
- 1 art gum or Pink Pearl eraser.
- 1 12″ x 18″ and 1 pocket-size drawing pad.
- 1 set of cake watercolors.
- 1 size 11 or 12 watercolor brush.
- Canteen with water cup.
- Paint rag.

The Small Sketchpad

The pocket-size sketchbook is good for recording momentary experiences in a kind of "shorthand." A particular gesture or pose, light on leaves, a cloud formation—these are the kinds of spontaneous events that may later be included in a painting. The pad and a pencil should become as much a part of your daily requirements as keys and a purse or wallet.

Figure 1.5

Figure 1.6
PETER S. S. WILSON
Shelter in an Old Barn (ballpoint pen).
Courtesy of the artist.

This Scottish artist finds the
5″ × 7″ sketch pad indispensable for
recording impressions while bicy-
cling through the county of Clack-
mannanshire.

The Large Sketchbook

Following are some suggestions, as well as
exercises (designated by a number in paren-
theses), to get you started with your 12″ x 18″
sketchbook and new equipment.

PENCIL DRAWING

Try these two approaches:

*(1) As you talk on the telephone, without thinking
you may find yourself doodling with a pencil and pad.
What you may not realize is that many artists use that
very approach to develop new ideas. Using the soft 5 or
6B pencil, only bluntly sharpened, bear down to create a
pattern of doodled, black lines. Keep them free flowing—
no need for an eraser. Then, alternating between the soft 5
or 6B and the hard 2H pencils, make both black and grey
inner patterns or textures.*

*(2) Since the pencil is our most commonly used tool,
a word of caution is necessary to avoid a pinched or*
*halting technique based on handwriting. The beauty of a
freely flowing line comes through using the pencil as
though it were an extension of the arm. Although detail
requires finger control, Figure 1.7 demonstrates two ways
of holding the pencil that will enable you to develop a more
rhythmical line quality. Practice both ways. Again, since
drawing is exploratory in nature, avoid dependency on
erasing.*

*Aside from the 2H pencil, varying tones of grey are
produced by overlapping a series of intersecting lines in a
technique called* crosshatching. *A good place to start is
with dried nature forms. Even the common thistle can
have great beauty.*

FELT TIP PENS

These pens are handy to carry and are a
logical way of introducing color in your be-
ginning drawings. Drawing with felt tips adds
a new dimension in that it gets you to think in
terms of "areas of color," an important con-
sideration in painting.

Figure 1.7
Doodling allows free play of the imagination.

Figure 1.8

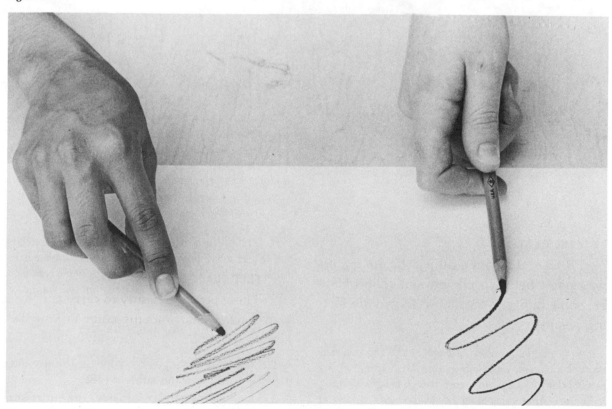

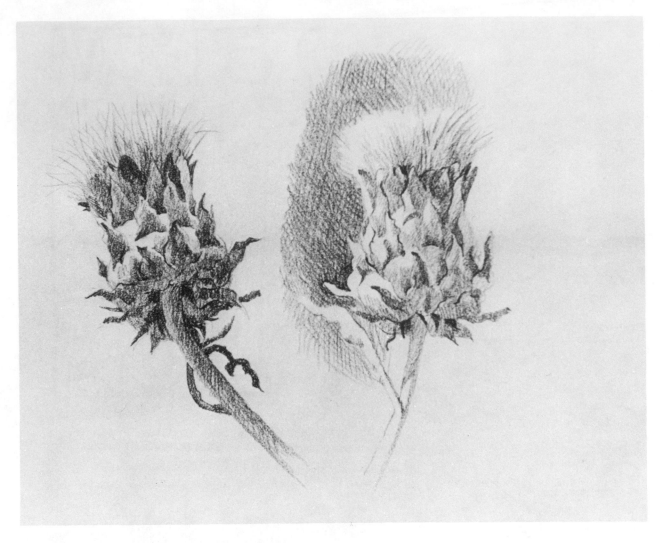

Figure 1.9
WAIF MULLINS
Thistle Study (soft pencil).
Courtesy of the artist.

By crosshatching, the artist develops a sense of light and shade.

OIL PASTELS

Rich and creamy, oil pastels are a half-way point between crayon and chalk. Here are some things to try that will yield interesting results:

(1) Again, thinking "areas of color," choose a view through a window and simplify it to flat shapes. You are now working like a painter even though using a drawing technique. After completing the shapes, add details or lines.

(2) Scrafitto is a technique based on scratching through an upper layer of pigment to reveal what is beneath, achieving a color interaction much in the manner of many applications of paint flaking off an old wall.

Some other suggestions are:

1. Plan simple shapes of color on the drawing paper according to the subject idea.
2. Lay on additional colors over the entire surface until the preliminary drawing is obscured.

Figure 1.10
TERRY REYNOLDS
Felt-tip experiments (colored felt-tip pens).
Courtesy of the non–art-major student.

These imaginative sketches were among the first drawings done by this student.

Figure 1.11
LAURA WELTY
Window View (oil pastel).
Courtesy of the student artist.

Oil pastels are softer than crayons, so a richer surface can be developed.

You may also work on colored construction paper.

3. Using a pointed knife tip, scrape back through the layers of oil pastel to reveal the colors beneath. In this way you can develop a delicate "tracery" of lines and colors.

(3) Resist is a method of working that depends on the difference between water and oil being used as the mixing agent for colors. First, make a heavy application of oil pastels *in a linear fashion, allowing blank areas of paper to show. Using plenty of water and pigment, mix colors in the lid of your paint set. As you brush the paint across the drawn surface, you will see the oil pastels maintain their clarity as they resist the watercolor. The interaction of paint and pastel provides colorful results.*

Even before delving into painting fundamentals, you will find yourself responding to the creative "spark."

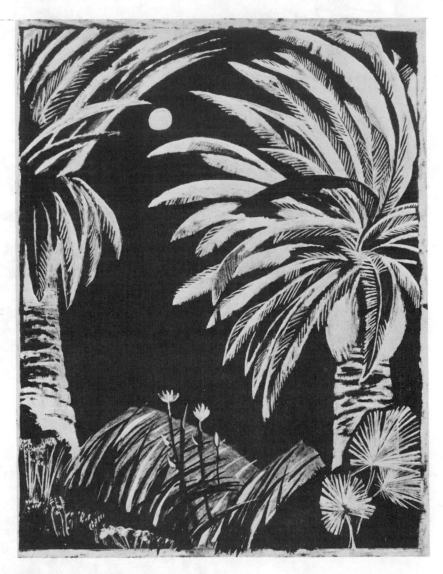

Figure 1.12
RUTH ORMEROD
Palms (oil pastel scrafitto).
Courtesy of the artist.

Delicate lines and surfaces can be incised using the scrafitto technique.

Figure 1.13
CHRIS FICKEN
Still Life (oil pastel resist).
Courtesy of the artist.

Unlike traditional pastel with its chalky quality, oil pastel is almost like paint in a stick form.

IMAGINE THAT YOU ARE STANDING in a field of wildflowers, and through trees you see the ocean beyond. Also within your vision is a weathered barn and a horse, its coat glowing in sunlight. With these visually exciting objects, how can you focus on the best subject for a painting? Simplifying personal experience is the first problem for the beginning painter.

In Chapter One we discussed the improvizational nature of recording sensations by means of sketching. To clarify further our search for the essential, let us examine subject matter from three basic standpoints:

1. Still life.
2. Landscape.
3. The figure and portraiture.

14

The subject: what shall I paint?

Still Life—The Controlled Environment

Even prior to painting, placing objects into a still-life arrangement is an act of composition. Just as rhythm is important to the musician, a kind of "visual rhythm" should be present in the selection of your materials (Plate 3). When objects are dissimilar, as in Figure 2.1, it may be necessary to find ways to establish a common denominator between forms. The scissors are angular, as are the shapes on the cloth, while the irregular outlines of the potato share that quality with the cotton blossoms.

The problem: Figure 2.2 illustrates a typical still-life setup with a tall wine bottle, the only vertical shape of its kind in the com-

Figure 2.1
RUTH ORMEROD
Still Life (gouache).
Courtesy of the artist.

Visual "shape rhythms" were stressed in this work.

Figure 2.2
When choosing still-life objects, remember that you
must deal with the space that surrounds them.

position. Since an elongated canvas would be necessary, how can one fill the space in the upper part of the painting?

By replacing the bottle with some additional objects more similar in size and shape, artists may interpret their subjects by concentrating on areas of major interest.

The great advantage of still life is that you can predict such variables as light and shade, as well as the placement of objects. This gives you time to construct relationships that might prove to be more elusive in landscape or figure painting. Here are some ideas on setting up a still life:

1. Don't begin with items that are difficult to paint, such as delicate ceramic figurines, intricate lace or metalwork, or highly reflective surfaces such as glass or metal.

2. When choosing subjects, consider the durability of your objects.

3. When setting up the still life, be aware of the importance of light. Just as a jigsaw puzzle is composed of pieces to form the completed picture, so a still life can be structured with areas of light and shade.

Finally, remember that the realm of still life is as broad as any other art form. Consider these few examples of some student projects: a leather jacket draped over a mo-

Figure 2.3
These objects require less background space.

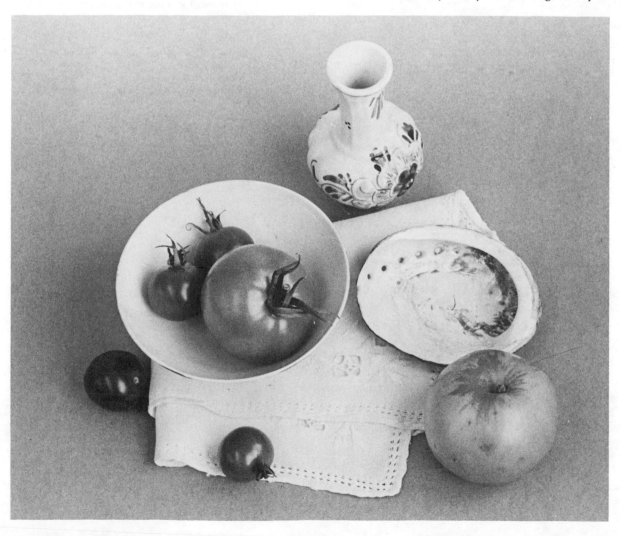

Figure 2.4A
MARY ZOE KEITHLEY
Reflections (oil).
Courtesy of the student artist.

This advanced student had the background to work with highly reflective surfaces, but this is not recommended as a beginning project.

Figure 2.4B
KATHIE BECHARD
Broken Window (watercolor).
Courtesy of the student artist.

Equally difficult is the capturing of dusty glass through which vague images may be seen.

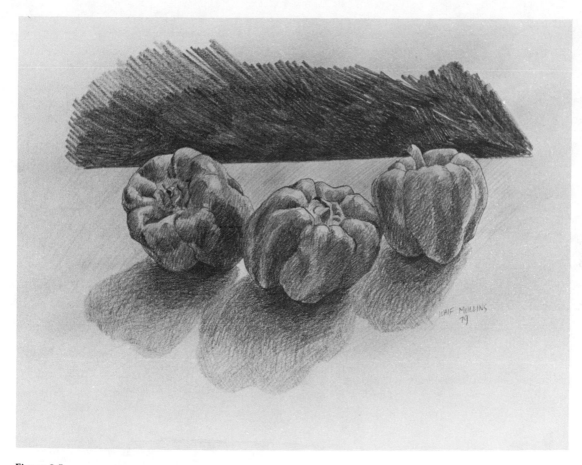

Figure 2.5
WAIF MULLINS
Study of Peppers (soft pencil).
Courtesy of the artist.

Objects such as peppers, acorn squash, or onions have a relatively long life,
whereas flowers require a speedier work time.

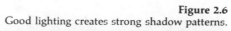

Figure 2.6
Good lighting creates strong shadow patterns.

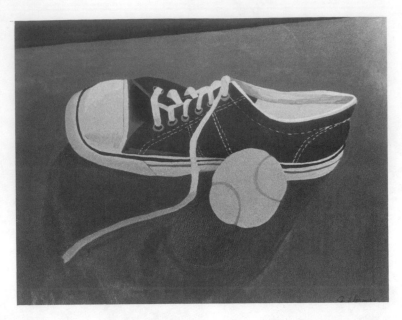

Figure 2.7
JILL WARNER
After the Game (gouache).
Courtesy of the non–art-major student.

Still-life subjects can reflect your personal interests.

torcycle, objects reflected in a broken mirror, an open box of candy, a saddle, a produce stand, a gumball machine, and a bowl of goldfish.

The student work seen in Figure 2.8 adds another element—social commentary—to the possibilities of still life.

Mature artists also find still life as open to exploration as any other form of painting. Joan Irving (Plate 3) gives us a sense of well-being by her choice of colors, as well as a window view of the sea and sails in summertime.

Figure 2.8
MARK FROHMEYER
Cheaper by the Dozen (watercolor).
Collection of Mr. and Mrs. Walter Mosher.

An anti-war statement, this painting was the result of the young artist's discovery of tarnished medals of heroism languishing in a cigar-box display of a secondhand shop.

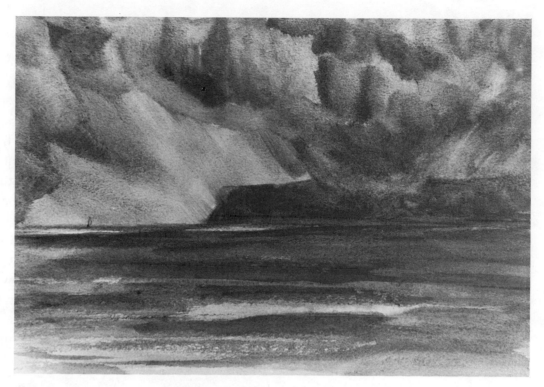

Landscape—Ever Changing in Mood

Nineteenth-century landscape painters made a major contribution when they moved the easel from the rarified air of the studio to an outdoor confrontation with the light and color of nature. Capturing the mood of a specific time and place was a strong motivation for American artist Winslow Homer (Plate 4). It was that impulse that led to my attempt to crystalize a feeling about a peaceful summer afternoon in *The Sprinkler* (Plate 5). This particular subject was also across the street from my studio, and therefore a familiar view. Knowing your subject well often leads to a greater insight into its interpretation.

Another aspect of painting directly from nature is that you become sensitive to changes in your surroundings. How different from *The Sprinkler* is the feeling conjured in the painting of a coastal rainstorm. This "felt" response need not be visual at the outset. For example, Arthur Dove made a very successful painting of something heard.

Figure 2.9
EVELYN G. SHULTZ
Point Loma Squall (watercolor).
Courtesy of the artist.

The subject of this painting is not only a coastline, but climatic conditions as well.

Figure 2.10
ARTHUR G. DOVE
Fog Horns (oil on canvas, 17¾″ × 25½″).
Colorado Springs Fine Arts Center Collection, anonymous gift.

These "bloopy" shapes suggest the sounds of distant fog horns.

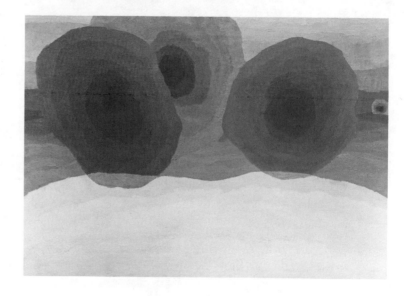

The Figure and the Portrait— A Feeling for Life

Capturing a quality of life on the painted surface has fascinated artists throughout the history of art. Paleolithic cave painters may not have considered themselves artists in the modern sense, but their beasts still appear to live.

There are two basic approaches to what is termed *figurative* painting. One approach is the figure in the environment. At times, as in Figure 2.12, the figurative aspect is so great in paintings that the environment plays only a supportive role. In contrast, the figure in this student work is utilized as a point of interest in a larger scheme.

Another approach is portraiture. Figure 2.14 reveals the fine line between what could be called figure painting, landscape, or portraiture. Here the figure is a tiny part of the whole, but is in fact a self-portrait.

A fusion of portraiture and the environment typifies a traditional approach to capturing personality. The boy in Figures 2.16 A and B is shown with his pony at the stable. The environment tells us of the boy's interests, as well as serving as a compositional support structure for the central figure.

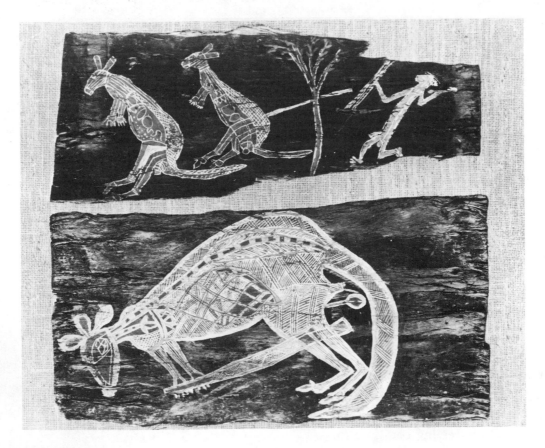

Figure 2.11
ANONYMOUS
Kangaroo-Man Kandarik (tree bark).
UNESCO World Art Series, published by the New York Graphic Society.

Even in recent times, in such areas as western Arnhem Land, Australia, primitive cultures have produced lively works.

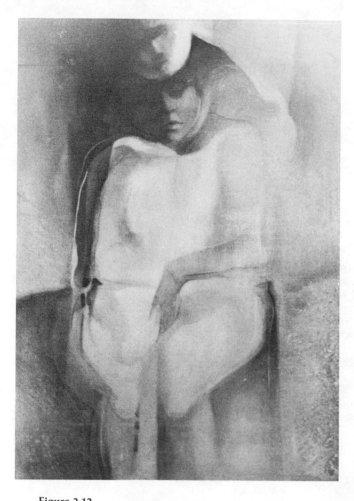

Figure 2.12
KEN MORROW
Mourner (acrylic).
Courtesy of the artist.

Large, powerful figure pieces typify this artist's work.

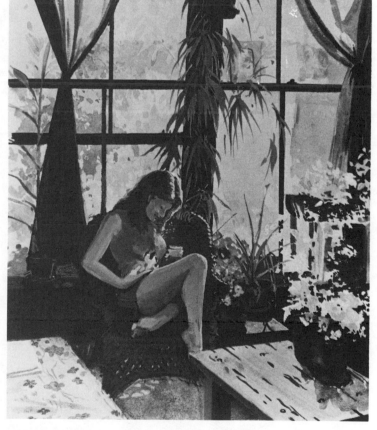

Figure 2.13
GARY GOUNDREY
Sunlit Room (gouache).
Courtesy of the student artist.

Here the figure serves as a point of interest, the major theme being a room bathed in sunlight.

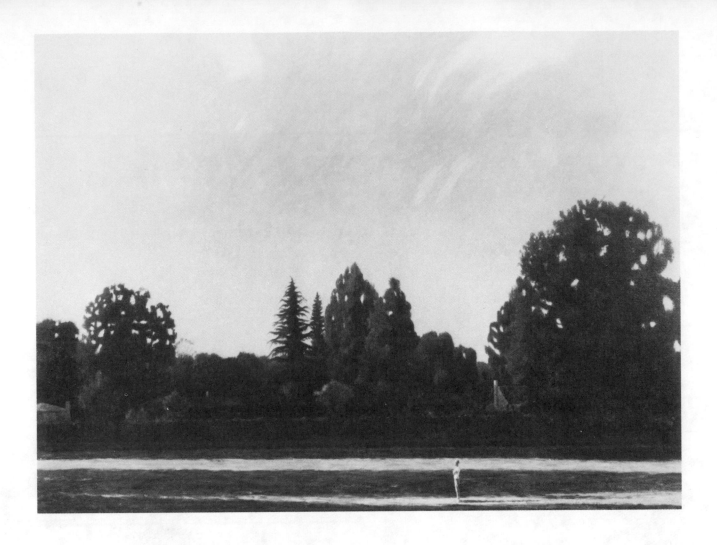

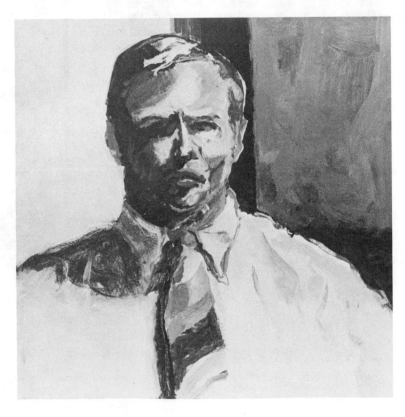

Figure 2.14 (above)
THOMAS GRIFFITH
Sunset Self-Portrait (oil, 35″ × 47″).
Courtesy of the Lew D. Oliver Memorial Collection.

This painting began as a landscape, and only as I was finishing it did I decide to include the self-portrait.

Figure 2.15 (left)
JEFF NELSON
Self-Portrait with Striped Tie (oil).
Courtesy of the artist.

In most cases, the portrait attempts to probe the personality or mood of the sitter, as does this self-portrait.

Figure 2.16A (opposite, top)
THOMAS GRIFFITH
Thumbnail sketch of Peter Dunlap (pencil).
Collection of the artist.

Prior to painting, various preparatory studies were made.

Figure 2.16B (opposite, bottom)
THOMAS GRIFFITH
Peter Dunlap (oil).
Courtesy of Mr. and Mrs. Lennis Dunlap.

Including the environment can be a descriptive aid in portraiture.

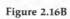

Figure 2.16A

Figure 2.16B

SUGGESTED EXPERIENCES— choosing your subject

As an aid to organizing, in addition to carrying a sketchbook, take along a 35mm slide mount with the film removed and use it as a window to see possible subjects. Not only does it serve as a composition frame, but it can be a perspective aid as well (see Appendix). And through the use of a sketch-file system, or a cupboard set aside for the purpose, store ideas and objects of interest that might otherwise be forgotten—a sort of "subject matter" bank.

Warm-up Exercises

Using the same materials as in Chapter One, try the following ideas.

STILL LIFE

On a table near a window, experiment as follows:

Place a square cloth of a single color or simple pattern. On the cloth, place a bowl that is slightly smaller in diameter than the width of the cloth. Place simple objects such as lemons, pears, apples, or bananas in the bowl and several on the cloth. Using the 5 or 6B pencil, draw a square, as well as a vertical or horizontal rectangle on a sheet of your drawing paper. A ruler would help you keep the edges equidistant. Draw with line first, then fill in

Figure 2.17
Dried plant or skeletal forms, gourds, shells, and interesting containers are the kinds of objects that may be easily stored.

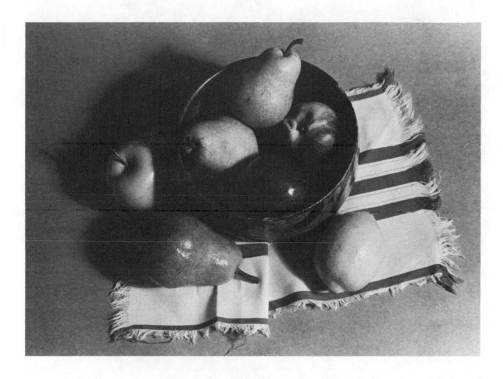

Figure 2.18

Figure 2.19

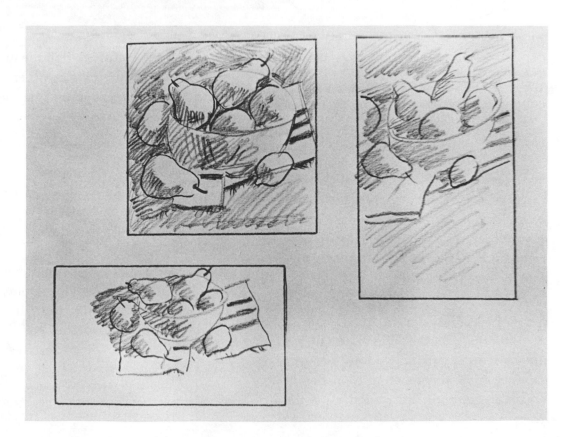

Figure 2.20
The final version, utilizing oil-crayon–watercolor resist.

areas with some middle tones and darks. In which shape does your still life best fit? Again, these thumbnail sketches prepare you for the final composition. You can now do a larger version in color, using the techniques described in the last chapter.

The idea of making your still life "compact" rather than having small objects lost in a page of space can be approached in another way. Fill the picture area with the subject of major interest by moving in and allowing segments to touch or go beyond the edges of your picture (Plate 6).

LANDSCAPE
Enlarging on the slide mount idea, cut a square or rectangular "window" in a piece of paper of approximately 6 to 10 inches. Using a magazine or book illustration, move the aperture over the picture to find the most interesting arrangement. This can then be interpreted in a simple fashion, using the materials you already possess.

THE FIGURE AND THE PORTRAIT
"I'd really like to draw and paint my pets and family, but whenever I try they come out like disjointed paper dolls. Besides that, they won't hold still long enough." This is a typical statement by the beginning painter, and justifiably so. Working from life is a challenging problem (Plate 7). It might be best if we investigate the possibilities in stages as in the following exercises.

(1) Choose a photograph of a subject that interests you, looking for the "mysterious" quality of shadows.

Using the soft 5 or 6B pencil, recreate the pattern of light and shade that you see.

(2) Place yourself near a window for a similar light effect and make a pencil drawing of your own features. The self-portrait is a good means of developing the ability for keen observation.

(3) Work from life by including sleeping figures that are going to be holding their position for a period of time.

If this is an approach to portraiture, you should at the same time be developing the skill of *animating*, or bringing a liveliness to the figure. "Gesture" drawings are quick notations of movement that are indispensable to the figure painter. Make a habit of carrying your small sketch pad to record the character of a momentary gesture or movement.

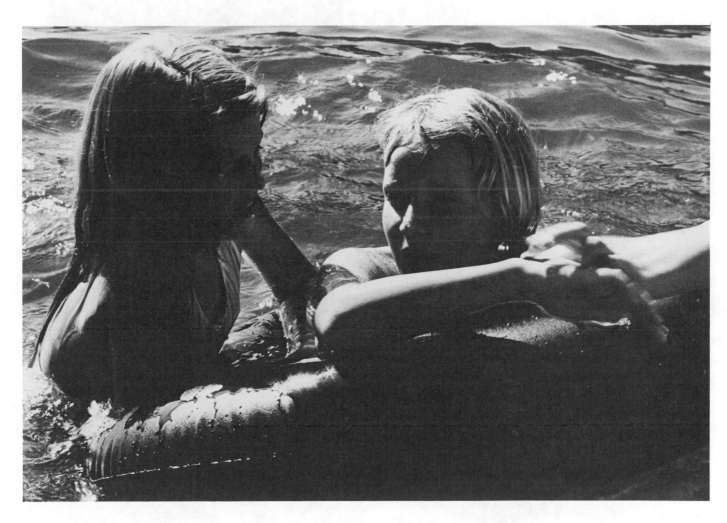

Figure 2.21
MICHAEL SIMMONS
Friends (photograph).
Courtesy of the photographer.

Impact is gained through limiting the amount of white in a composition.

Figure 2.22
SANDRA PETERSEN
Self-Portrait (pencil and watercolor).
Courtesy of the student artist.

The model is readily available when it is you.

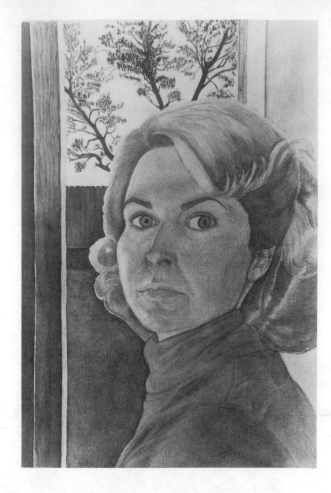

Figure 2.23
RUTH ORMEROD
Cat Nap (pastel).
Courtesy of the artist.

The task is easier when the model is in repose.

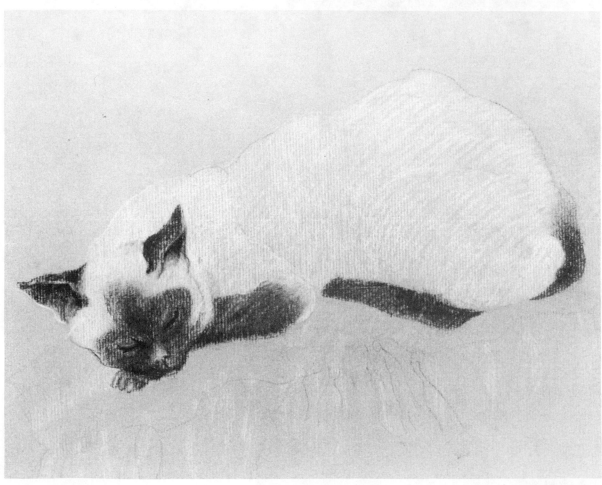

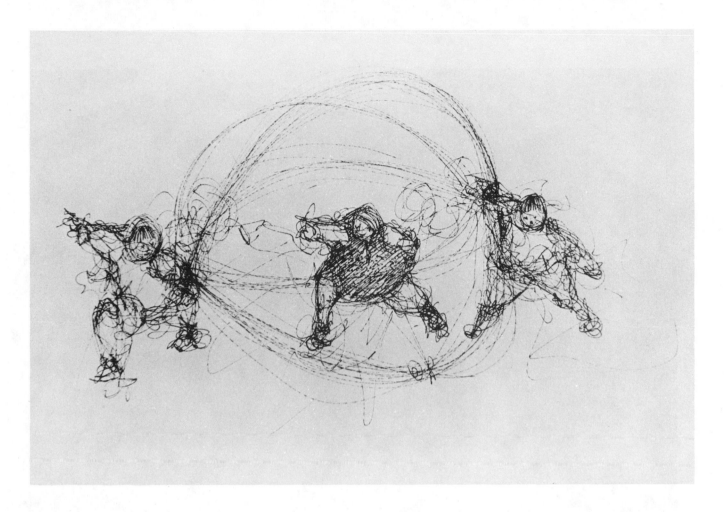

Figure 2.24
GIETY MOAREFI
Jump Rope (felt-tip pen).
Courtesy of the artist.

Gesture drawings record the action of a moment.

Seeing and Feeling

A broad range of experiences occur in our daily lives that are potentially subject matter for paintings. Try interpreting music, a breeze, or human emotions such as love, hate, or fear. If you contrast Figures 2.25 and 2.26, you will see that there is more than just a difference in subject matter; the harsh angular-ity of one speaks of the tensions of war, while the calm simplicity of the other is reminiscent of solitude.

Most important—be sensitive to your surroundings. Take a delight in the fleeting aspects of the world around you or the images that, once seen, may never recur in the same way. Whatever you see or feel is potentially a subject.

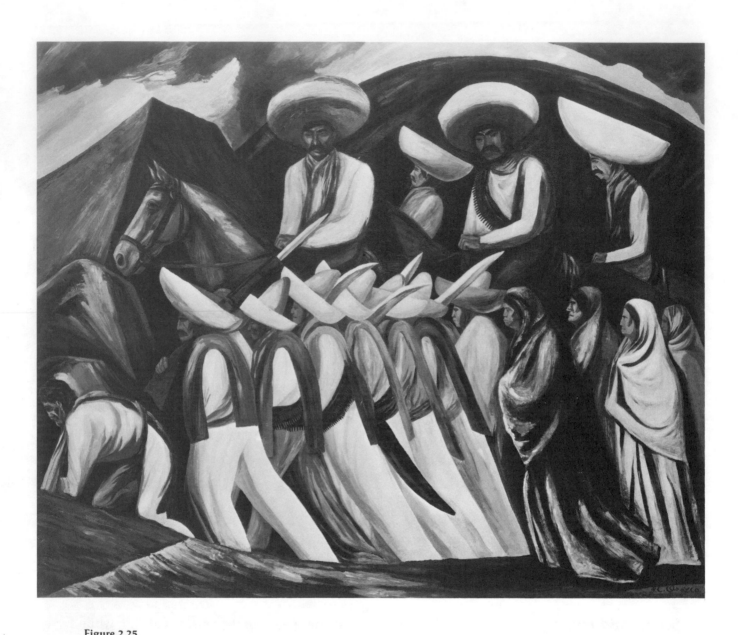

Figure 2.25
JOSE CLEMENTE OROZCO
Zapatistas (1931) (oil on canvas, 45″ × 55″).
Collection, The Museum of Modern Art, New York; given anonymously.

The turbulence of modern events in Mexico is expressed vividly through Orozco's
"visual language."

Figure 2.26
THOMAS GRIFFITH
Poem (oil).
Collection of Frank Ficarra.

Memories of my grandfather reading on a quiet afternoon formed an indelible image on my mind.

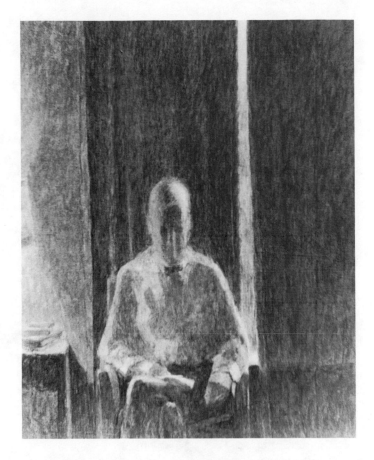

Figure 2.27
RICHARD HORNADAY
Old Collection (pencil and charcoal).
Courtesy of the artist.

Even the simplest of objects, such as rusted nails and bits of metal, can have personal meaning for the artist.

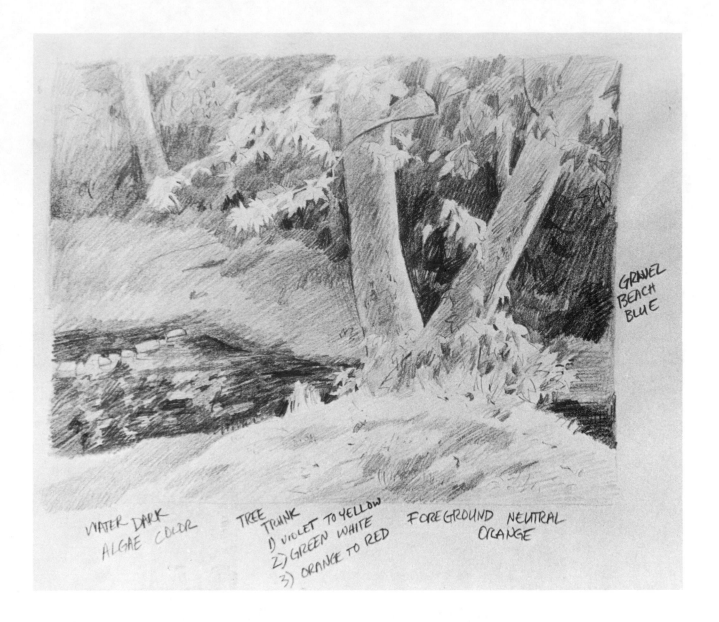

WATER DARK ALGAE COLOR

TREE TRUNK
1) VIOLET TO YELLOW
2) GREEN WHITE
3) ORANGE TO RED

FOREGROUND NEUTRAL ORANGE

GRAVEL BEACH BLUE

S INCE BUILDING SELF-CONFIDENCE IS VITAL in any new venture, it is important to gain encouragement from associates who are also involved with mastering new techniques and concepts. We tend to be overly self-critical, so our work needs to be seen through the eyes of others. If you are not in a structured class, it would be helpful to find a sympathetic friend to accompany you.

Let us follow the development of some beginning painting students as they progress from exploratory drawings to their first efforts at painting. Before starting a field trip, we will first need to add some new supplies to our earlier list.

- Charcoal pencil.
- Several sticks of vine charcoal.
- 1 stick of compressed charcoal.
- 1 each of red, brown, white, and black conté crayon.
- Kneaded eraser for charcoal.
- Paper stomp for rubbing charcoal or pastel.

34

CHAPTER THREE

A field trip

- Pen holder with a B-6 point.
- India and/or sepia ink.
- Sizes 6 and 12 watercolor brushes and/or Oriental brush.
- Saucer or chicken pie tin for thinned ink.
- 1 box of pastels.
- 1 sheet of scratchboard and a scratch tip (individual scratch tips can be inserted into the pen handle).
- Crowquill pen.
- 2 sheets of student grade watercolor paper.
- Lightweight drawing board.

Once on the site, each person experiments with different drawing techniques. One technique is *charcoal*, which gives rich greys and blacks. It is ideal for building middletones and darks. The necessary supplies include three types of charcoal. One is *vine charcoal*. A very soft form of the medium can be rubbed into the paper with a bit of wadded paper, a paper stomp, or even the finger. Its softness makes it easy to lift with the kneaded eraser to reveal the original

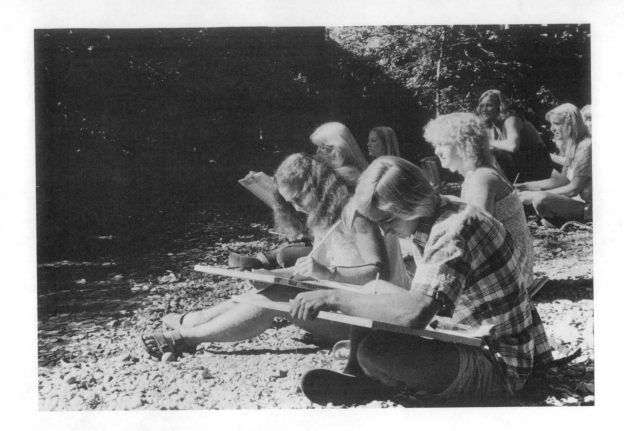

Figure 3.1 (above)

Figure 3.2 (left)

Figure 3.3 (below)
Left to right: vine charcoal (very soft), compressed charcoal (very black), and charcoal pencil (for the drawn line). Also included: kneaded eraser and paper stomp.

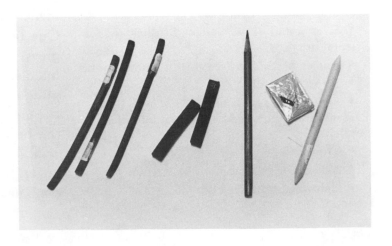

paper surface. *Compressed charcoal* is extremely black, and its density makes it harder to erase. A new area of thought for the beginner is picture making by means of light, middle tone, and dark shapes rather than the drawn line. Just as you found when using drawing pencils, if line, crosshatch, or sharply defined edges are desired, the *charcoal pencil* is an important tool. Since all forms of charcoal are highly destructible, it is necessary to spray the surface with charcoal fixative. Once sprayed, the drawing will no longer be erasable.

Another technique is *conté crayon*, which gives added richness. In addition to black, conté crayon is available in earth oranges,

reds, sepia (deep brown), and white. Less powdery than charcoal, its waxy hardness makes it difficult to erase. For ease of handling, a number two or three grade of softness is preferable.

A third technique is *pen and ink*, for incisiveness. As mentioned earlier, overdependency on erasing can be crippling to rhythmical line flow. For this reason, the use of ink aids in breaking the erasing habit. In addition to sketching with felt tip pens, India or sepia inks have strength and durability and make effective lines with a sharpened stick, bamboo pen, or steel-tipped pen. The B-6 pen point is recommended because its well holds more ink than the conventional steel tip.

Figure 3.4
RUTH ORMEROD
Morning Glory (compressed charcoal).
Courtesy of the artist.

There are no drawn lines in this work

Again, the use of crosshatching is a valuable technique to achieve tone.

After developing some skill with these pen-and-ink methods, you may want to try a very delicate drawing tool. Although somewhat harder to handle, the crowquill pen is versatile, making narrow or wide lines according to the amount of pressure used.

For another effect, thin some ink in the saucer or chicken pie tin. This grey "wash" can be flooded into areas to work as a counterpoint to pen or brush-drawn lines. The wash is most effective when applied loosely, as if the brush were a mop. The size 6 brush is adapted to line, the size 12 to either line or wash, while the Oriental brush can be used for both wide or thin lines as well as the wash.

Another technique is *pastel*, drawing with color. The advantage of beginning with pastel is that the technique is similar to that of charcoal, but with the added dimension of color. Color richness of pastels is enhanced by working on toned charcoal papers, available by the sheet. Individual drawn strokes

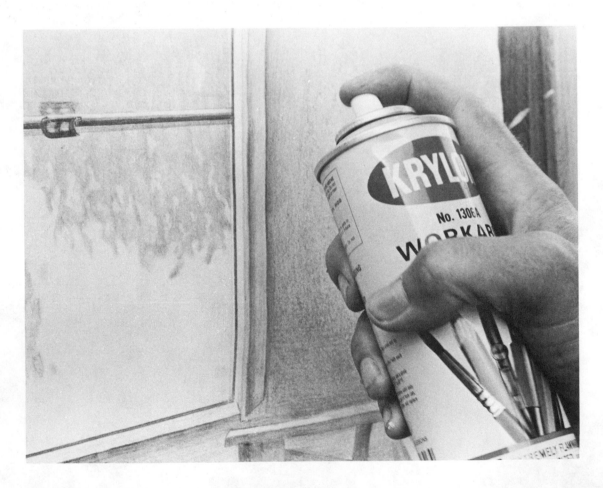

Figure 3.5
Apply fixative with a moving hand, according to the instructions on the label.

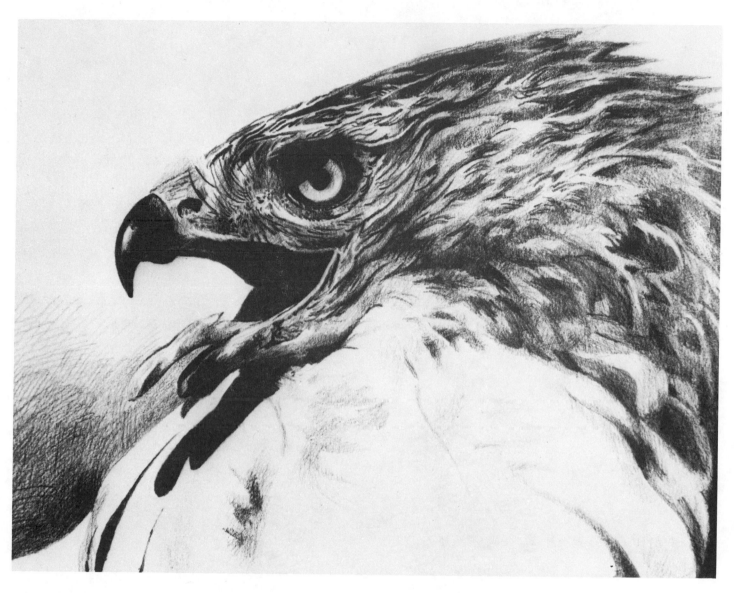

Figure 3.6
WAIF MULLINS
Red-tailed Hawk (conté crayon).
Courtesy of the artist.

The dramatic force of black conté crayon is evident in this work.

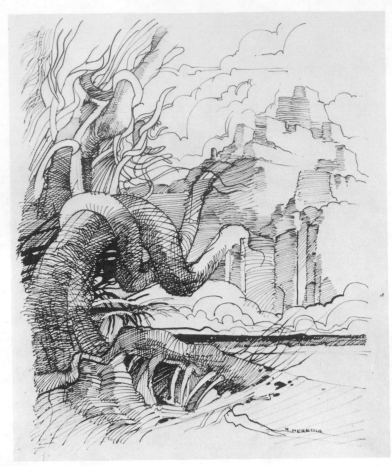

Figure 3.7
RUBEN HEREDIA
Nature Forms (pen with a B-6 point).
Courtesy of the artist.

If you like drawing, pen and ink is a must.

Figure 3.8
THOMAS GRIFFITH
Fern Palms (crowquill pen and ink).
Collection of Brenda Milbourn.

The crowquill seemed best suited for interpreting this variety of palm.

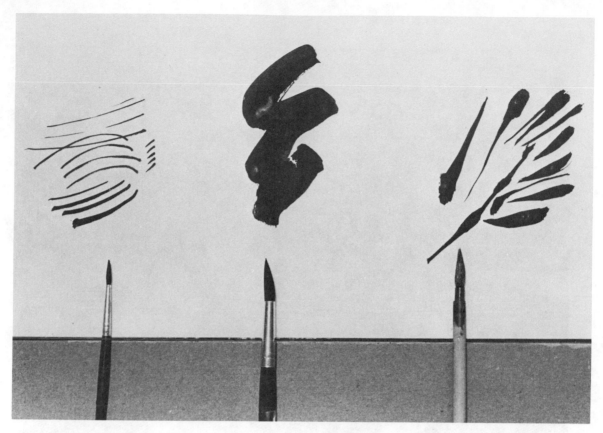

Figure 3.9
Left to right: watercolor brushes and their characteristic marks; sizes 6, 12, and Oriental.

interact with the paper, while smooth effects are also possible by rubbing with the paper stomp or finger.

SUGGESTED EXPERIENCES— evolution of a painting

Succeeding chapters deal with information that will help you grow as a painter. On this field trip, however, involvement does not require formal training. Looking over the shoulder of Robin Carnes in order to see her progress, you can follow the same sequence in your own work.

Selecting the Subject

(1) Using the slide mount, find an arrangement of shapes and colors that interests you.

(2) Make thumbnail sketches to determine whether the subject will best fit into a square, vertical, or horizontal format.

Developing the Subject

(1) Within a drawn rectangle or a full sheet on the drawing pad, block in the shapes you see in a simple manner with compressed charcoal. Concentrate on building dark, middle tone, or light shapes instead of lines.

(2) Develop color in the same way with pastel. See if you can include some of each color available to you and experiment with drawing smooth areas, dots of color, and drawn lines.

Painting the Subject

(1) The technique of watercolor will be discussed in Chapter Six, but for this introduction, tack or tape two quarter sheets of watercolor paper to the drawing board. Block in your subject lightly with the soft pencil. Do not do a finished drawing—these are merely guidelines.

41

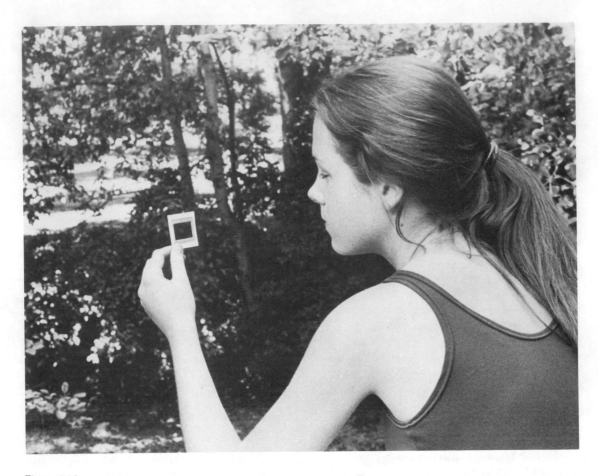

Figure 3.10

Figure 3.11

42

Figure 3.12

Figure 3.13

(2) Remember to leave areas of blank paper where you want white, since there is no white paint in the set. Start blocking in large shapes with your size 12 or ¾-inch brush. Don't be afraid to include plenty of pigment in the fluid wash of color.

(3) In the final stages of the painting, apply lines, textures, or darker areas of color.

After you return to the studio, your ideas gathered in the field can be expanded with some additional approaches, discussed in the exercises below.

(1) Nonbrush painting. Add assorted patterns and shapes by using a variety of means other than painting directly with the brush.

(2) Resist—another method of using the technique of watercolor resist is to apply petroleum jelly thinly to the paper, either prior to painting or between washes. Loosely woven materials such as lace can be treated with the jelly

Figure 3.14

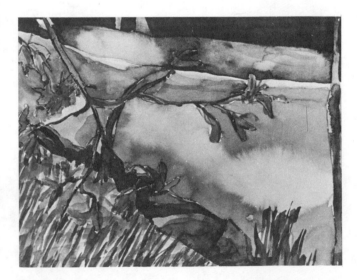

Figure 3.15
ROBIN CARNES
Creekside I (watercolor).
Courtesy of the artist.

Careful planning led to the successful completion of the outdoor phase of this project.

Figure 3.16

Figure 3.17A

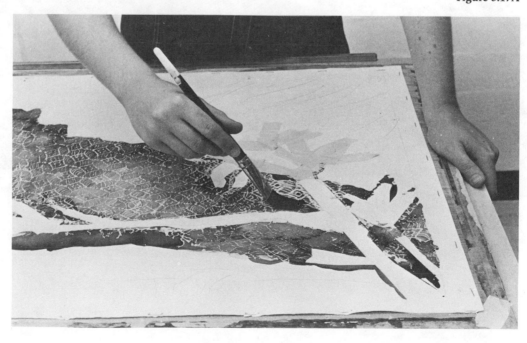

and pressed onto the surface of the paper. The watercolor wash affects only the areas where the jelly has not made contact with the paper. Use the jelly sparingly, and it will disappear into the paper.

(3) Scratchboard is a delightful medium that can be used by both beginning and advanced painters alike. Cardboard surfaced with chalk, scratchboard is designed *for the scrafitto technique. It is particularly helpful in that it also is a nice combination of drawing and painting techniques. Watercolors or inks can be brushed onto the chalk area and allowed to dry. Images may be random or planned, since the scrafitto work may also be used for image making. A scrafitto tip can be purchased in an art store and then fitted into your pen handle. Seek ways to scrape away both lines and areas.*

Figure 3.17B
ROBIN CARNES
Creekside II (watercolor resist).
Courtesy of the artist.

In addition to resist and stamping with cardboard and a sponge, this work includes color washes over underpainted areas of gesso for texture (see the section on acrylic supplies, page 95).

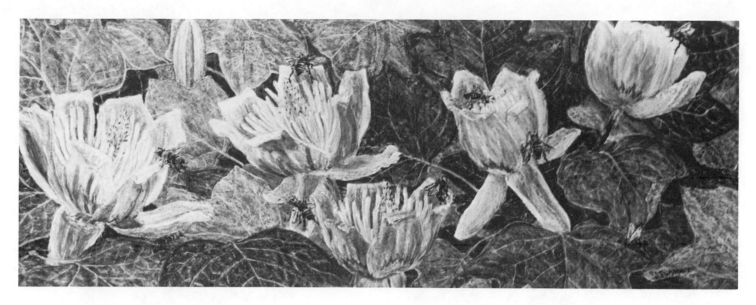

Figure 3.18A
JANET E. TURNER (National Academy)
Study for Bees in a Tulip Tree (watercolor on scratchboard).
Courtesy of the artist.

An internationally known printmaker, this artist finds scratchboard an excellent means for planning new works.

Figure 3.18B
RUTH ORMEROD
Northshore (watercolor on scratchboard).
Collection of Gus Biebert.

Scratchboard may also be considered a finished work in its own right.

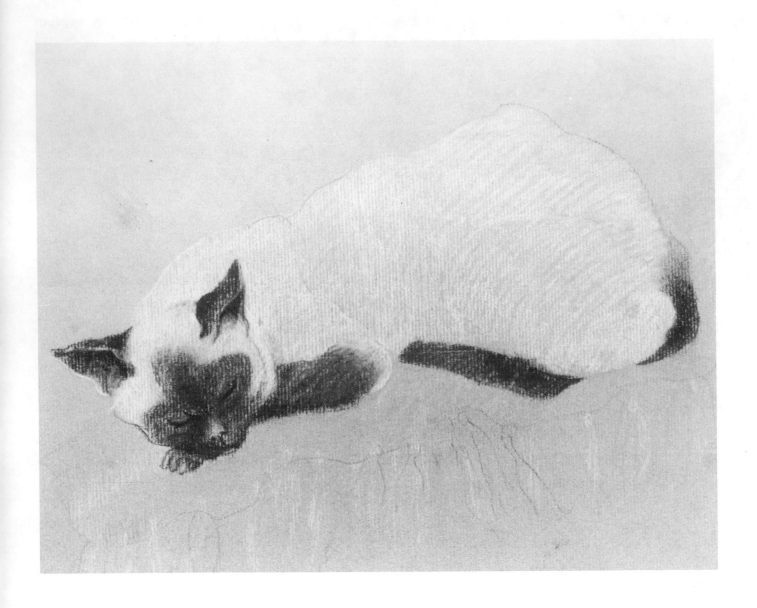

A T THE BEGINNING OF CHAPTER THREE, we stressed the importance of communicating with others about the progress of your work. Even at this early stage there is need to pause, reflect, and share your experiences in what we call the "critique." The purpose of the critique is not to criticize; it is to aid growth by means of a constructive, open-ended discussion.

ART-LANGUAGE TERMS

Following are some terms you will need in order best to express yourself when discussing art.

The *elements of art* define the means whereby we make a picture. The fascination in producing works of art comes from the

Building an art language

tremendous latitude of choices we have in applying the elements. For that reason these elements should be regarded as flexible guideposts:

- *Line as information*—just as a road sign gives directions, lines in drawings or paintings can impart information.
- *Line as edge*—the edge of a flat shape or the imagined contour edge of a three-dimensional object has a linear quality.

- *Line as expression*—just as your signature reveals certain aspects of your personality, so does the drawn line.
- *Texture*—textural or tactile qualities involve our sense of touch. We respond emotionally to surface feelings in drawings and paintings, which may function in two ways—actual textures exist in paper, canvas, or pigment, or textures may imitate those in nature.
- *Shape*—basically, all shapes are variations on the three shown in Figure 4.6.

Figure 4.1

Figure 4.2A
ANN PIERCE
Patterns (watercolor).
Courtesy of the artist.

Lines tell us, "Go right or left, up or down."

Plate 1
ALLEN STENTZEL
Birch Trees (watercolor, 10" x 12½").
Courtesy of the artist.
The glowing light quality on these trees is the result of close observation.

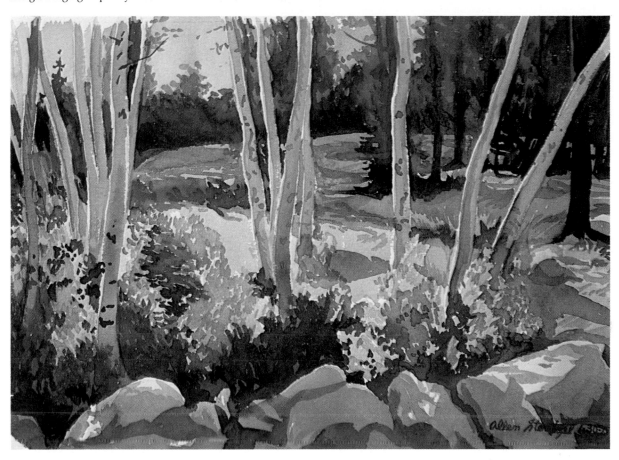

Plate 2
EUGENE DELACROIX
Arabs and Horses near Tangiers (watercolor).
Permission of the Fine Arts Museums of San Francisco; Achenbach Foundation for Graphic Arts; Mildred Anna Williams Fund, 1951.35.
Delacroix made many preparatory drawings and sketches for his paintings.

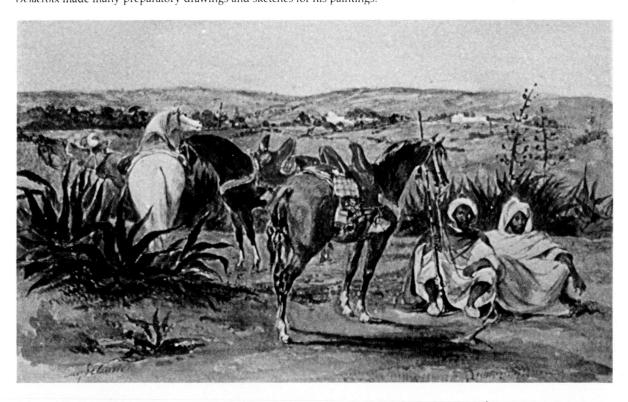

Plate 3
JOAN IRVING (American Watercolor Society)
From My Window (watercolor).
Collection of Helen Hand Zillgitt.
This watercolor displays a variety of techniques: wet into wet, wet on dry, and dry brush.

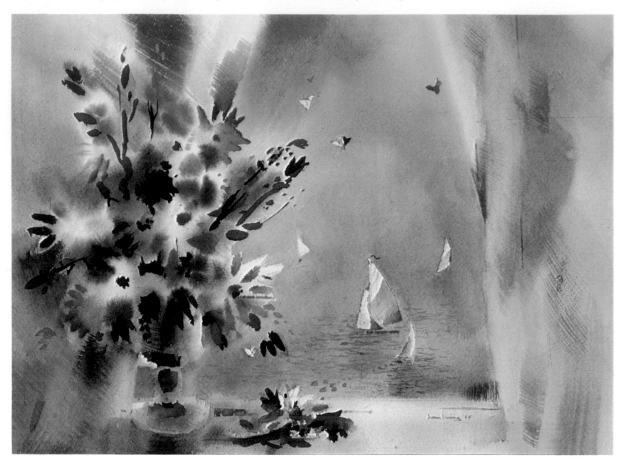

Plate 4
WINSLOW HOMER
The Pumpkin Patch (watercolor).
Mead Art Museum, Amherst College.
Homer was one of the first American artists to make watercolor a final form of expression, rather than a preparatory study for an oil painting.

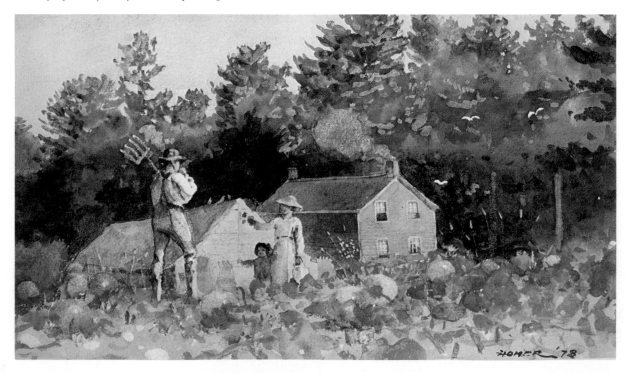

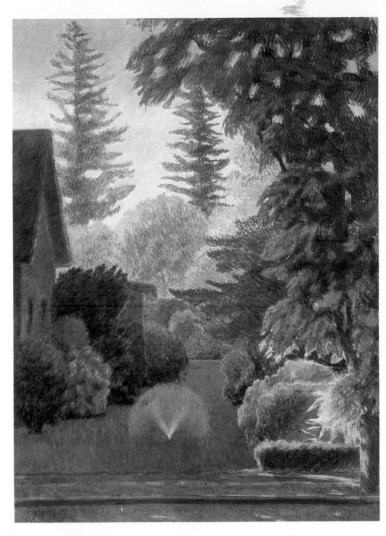

Plate 5
THOMAS GRIFFITH
The Sprinkler (oil, 18" x 24").
Collection of Mr. and Mrs. Peter Kuhlman.
How often I passed this way before realizing that it was a subject for a painting.

Plate 6
SHIRLEY PORTER (American Watercolor Society)
Cyclamen (watercolor).
Courtesy of the artist.
Direct communication with your subject can simplify composition problems.

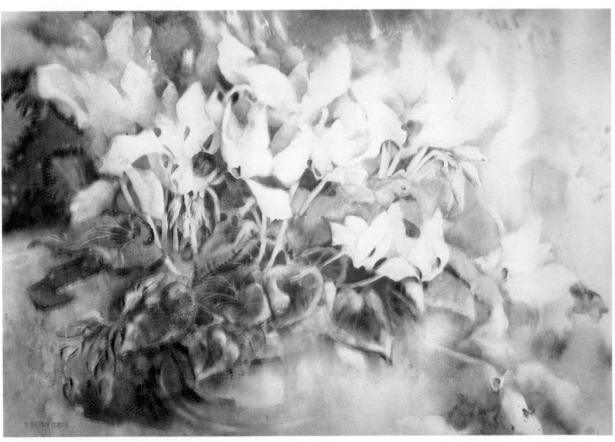

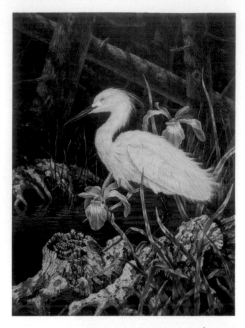

Plate 7
CHRIS FORREST
Egret (oil).
Courtesy of Chris Forrest Wildlife Studio.

When such exacting detail is desired, photography can be a valuable adjunct to painting.

Plate 8
THOMAS EAKINS
Max Schmitt in a Single Scull (oil, 32¼" x 46¼").
The Metropolitan Museum of Art; Alfred N. Punnett Fund and gift of George D. Pratt, 1934.

Eakins followed the procedure of first knowing the subject well and then capturing the expression of a moment in time.

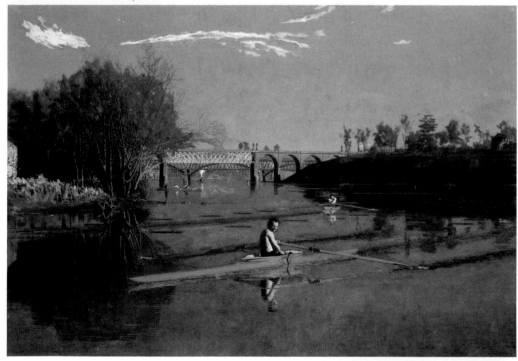

Plate 9
WAYNE THIEBAUD
Y Downgrade (oil, 22" x 18").
Courtesy of Allan Stone Gallery, New York.

This painting is a good summation of twentieth-century attitudes: the use of familiar subject matter without resorting to the traditional handling of space.

Plate 10 (right)
Color addition: By adding red, green, and blue color beams, television is able to produce all the hues, including white.

Plate 11 (below)
Color subtraction: The process of filtering energy from total white light reveals the individual colors of the spectrum. Here the three primaries are overlapped to produce additional colors.

Plate 12 (bottom)
This color wheel illustrates:
(A) The pigment primaries—cyan, magenta, and yellow—as well as colors that may be mixed through their use—vermillion red, emerald green, and blue violet. Any number of intermediate- range colors may be mixed, such as yellow-orange, orange, orange-red, and so on.
(B) In the inner ring, how colors can be neutralized by adding a small portion of the complementary color.
(C) A neutral color formed by mixing all the hues (the central dot).

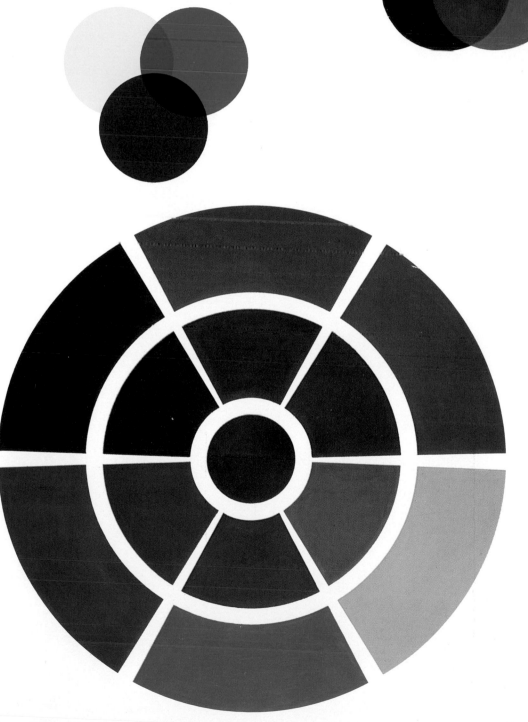

Plate 13

CLAUDE MONET

Two Haystacks (oil on canvas, 25½" x 39¼").

Collection of the Art Institute of Chicago; Mr. and Mrs. Lewis L. Coburn Memorial Collection.

Regardless of the images developed by Monet, his true subject was color itself.

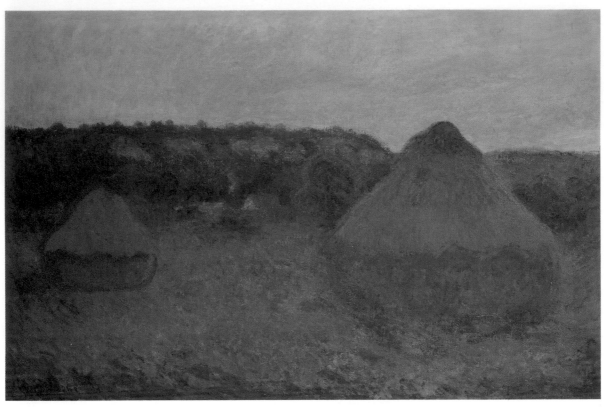

Plate 14

PIERRE BONNARD

Dining Room in the Country (1913) (oil on linen, 64¾" x 81").

Courtesy of the Minneapolis Institute of Arts; the John K. Van Derlip Fund.

Typical of Bonnard, he included the entire spectrum. How many yellows, reds, and blues can you find? Intermediate colors also include a range of oranges, violets, and greens.

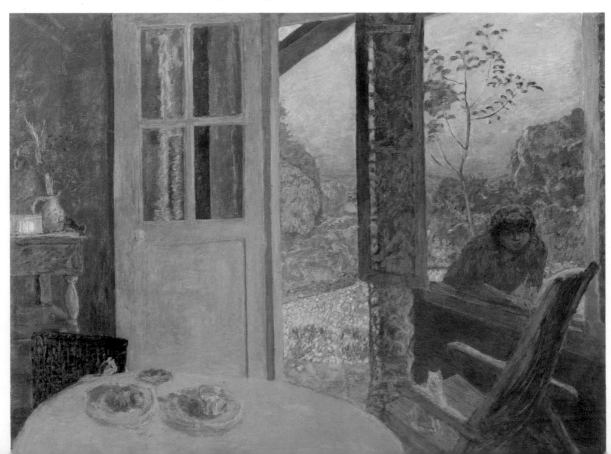

Plate 15
THOMAS GRIFFITH
Abalone Shells (watercolor, 9½″ x 12½″).
Collection of the artist.
This quarter-sheet watercolor was done with such small wash areas that stretching the paper was unnecessary.

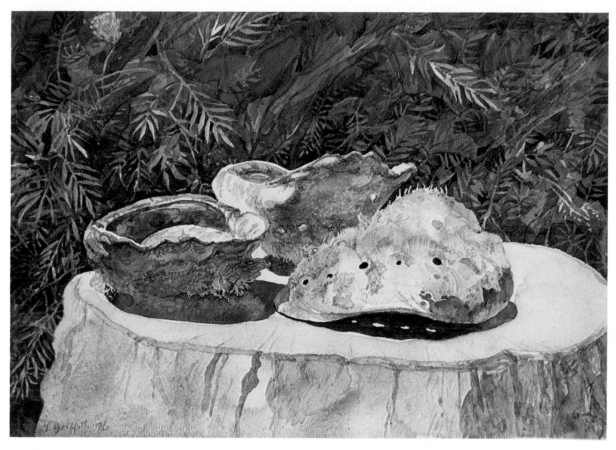

Plate 16
REX BRANDT (National Academy)
Bucolic Mood; Murietta (watercolor).
Collection of Mr. and Mrs. Clark T. Scarboro.
Tree trunks, birds, and wires, as well as details, were all added after the loose washes done on the wet paper were allowed to dry.

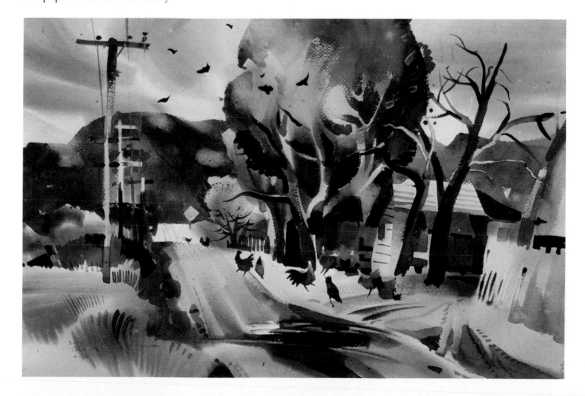

Plate 17
FRANCES HOAR TRUCKSESS
Moss and Lichen (watercolor, 21" x 29").
Collection of the artist.
The degree of wash dampness controls the amount of texture when using non-iodized salt.

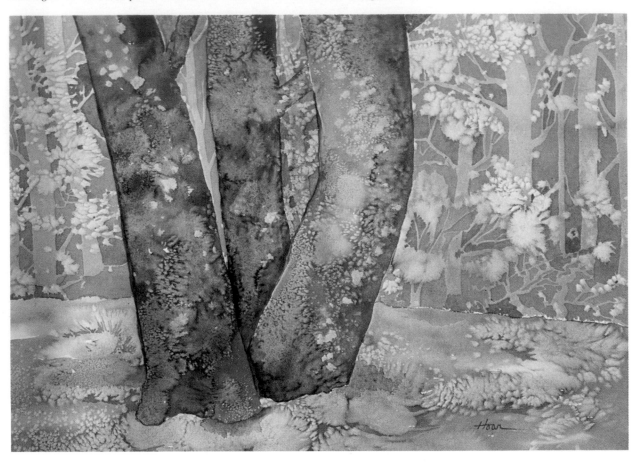

Plate 18
BRENDA MILBOURN
Morning Garden (oil, 12" x 12").
Courtesy of the artist.
By first establishing eye level and making a preparatory pencil drawing, the artist wedded linear and aerial perspective to form this sunlit garden area.

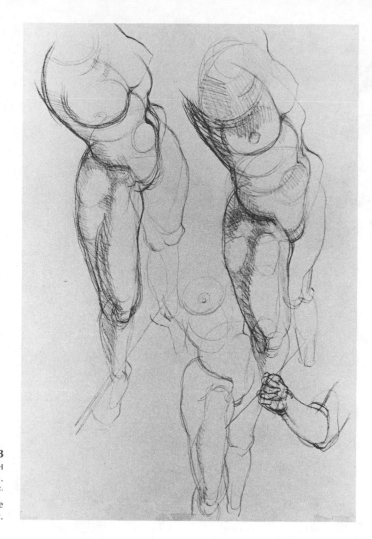

Figure 4.2B
THOMAS GRIFFITH
Life Study (conté crayon).
Collection of the artist.

To better describe solidity by use of line, I drew the figure as though it were transparent.

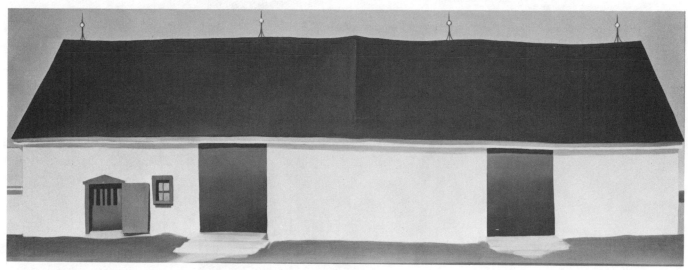

Figure 4.3
GEORGIA O'KEEFFE
White Canadian Barn No. 2 (1949) (oil on canvas, 12" × 30").
© Georgia O'Keeffe, The Metropolitan Museum of Art; Alfred Stieglitz Collection.

The crisp clarity of these shapes causes edges to have a linear quality.

Figure 4.4A
FREDERICK C. TRUCKSESS
Fallen Branch (watercolor and ink).
Courtesy of the artist.

Expressive line usage is termed *calligraphy*.

Figure 4.4B
MICHAEL MURPHY
Building Study (pencil).
Courtesy of the student artist.

A comparison of the same subject done by two students reveals how this person thought in a linear fashion to best express his feelings, whereas the example shown in Figure 4.5A is largely textural.

Figure 4.5A
MICHAEL PARDEE
Building Study (pen and ink).
Courtesy of the student artist.

This student made use of invented textures to interpret the subject.

Figure 4.5B
WILLIAM HARNETT
After the Hunt (oil).
Permission of the Fine Arts Museum of San Francisco, M. H. de Young Museum.

Master of the visual world, this nineteenth-century American artist made
an almost photographic imitation of real textures.

One of the overriding concerns of the artist is the choice of shapes employed. This sets the mood of the work.

• *Value*—light and dark considerations are of great importance to photographers and painters alike. By combining simple shapes with clearly stated values, the composition gains impact.

• *Color*—this element is of such vital importance to the painter, and takes such careful explanation, that all of Chapter Five is devoted to its nature and use.

The *picture plane* is the surface of the painting itself. Tied to how the artist solves problems relating to the picture plane are two concepts of space. The first is creating the illusion of spaciousness, as though we, the viewers, were looking at the world through a window. This attitude was so important to the nineteenth-century American painter Thomas Eakins that he did detailed structural drawings before beginning his paintings (Plate 8).

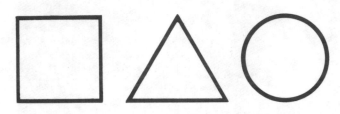

Figure 4.6

Figure 4.7
CHARLES DEMUTH
Stairs, Provincetown (gouache and pencil on cardboard 23½″ × 19½″).
Collection, The Museum of Modern Art, New York; gift of Abby Aldrich Rockefeller.

The artist's "shape language" tells us of rustic wooden architecture.

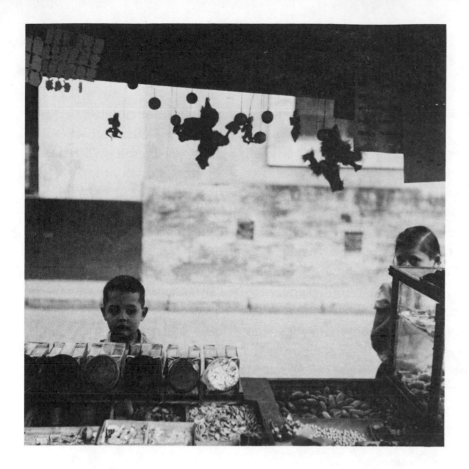

Figure 4.8 (above)
IRA LATOUR
Barrio, Seville, Spain—1953 (photograph).
Courtesy of the photographer.

As you make notes in the sketchbook, imagine that you are a photographer considering the impact of dark and light shape relationships so necessary for strong compositions such as this one.

Figure 4.9 (below)
THOMAS EAKINS
Perspective Drawing for John Biglen in a Single Scull (pen and ink with wash).
Courtesy of the Museum of Fine Arts, Boston; gift of Cornelius Whitney.

John Biglen and Max Schmitt (Plate 8) are only a few of the athletes so carefully analyzed with series of structural preparatory drawings by Eakins.

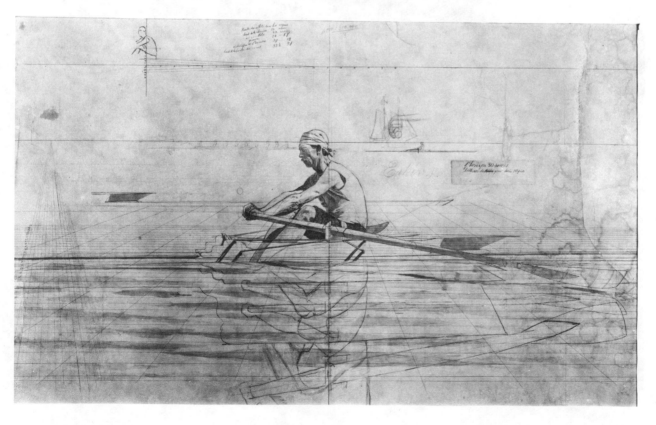

The second concept of space concerns distorted perspective. As opposed to illusory space, many contemporary artists distort perspective, thus emphasizing the essential flatness of the picture plane (Plate 9).

The three-dimensional quality of objects is referred to as *volume*. Equal to the challenge of making the picture plane appear to be airy space is the building of structurally or anatomically solid volumes.

To achieve the appearance of solidity, a careful consideration of *light source*, of how light falls on objects, is necessary. Traditionally, side lighting is most frequently used since that makes visible both illuminated and nonilluminated surfaces. However, the student still life shown in Figure 4.12 demonstrates how back lighting can dramatize the intensity of light.

Although *form* refers to volume, in a broader sense it refers to the work of art as a whole.

Composition, composing on the picture plane, requires that one translate what is in the mind's eye to the surface of the painting. When you choose a square or a rectangle upon which to work, you have made your first act of composition. From that point on,

Figure 4.10
RICO LEBRUN
Crucifixion (oil).
Courtesy of Syracuse University Art Collections.

Dramatic power is concentrated on the figures by enclosing them in a shallow spatial area.

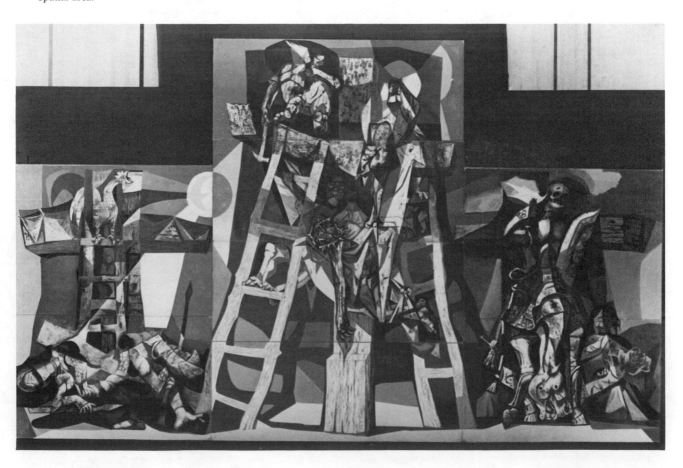

Figure 4.11
SCOTT HUDSON
Still Life (pencil and watercolor).
Courtesy of the student artist.

A strong light source aids in the building of volumes.

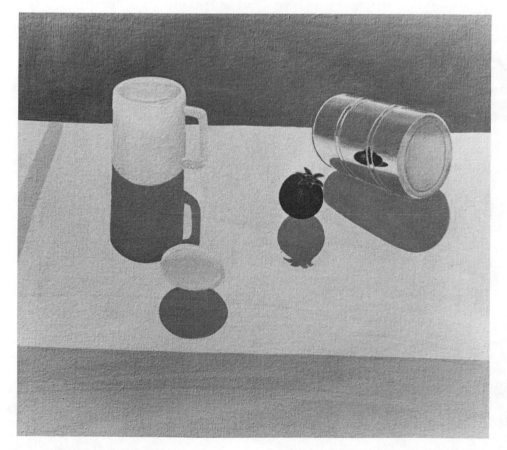

Figure 4.12
MARK BRAITHWAITE
Objects in Light (acrylic).
Courtesy of the student artist.

Light intensity supersedes volume building in this work.

on, each mark or color, whether random or planned, contributes to the character of the completed painting.

Repeated visual elements create *rhythm*, just as percussion might in musical form.

Again taking music as an example, a phrase may be introduced upon which variations are made. For *theme and variation* in the visual arts, a phrase may appear as a repetition of straight lines or curves.

Selectivity and *unity* are important. To gain a unified impression, one must ask one's self, "What is the feeling I am trying to impart?" One problem comes from the attempt to put too many ideas into a single painting.

The term *scale* refers to how large or small the parts of a composition seem to be.

Sharply differing light and dark, or colors such as red and green in adjacent positions, will create *contrast*, or contrasting areas that will dominate a composition. Less attention is attracted by low contrast.

The *support*, or backing upon which a painting is done, has many variations. Canvas, for example, has differing weights and textures, while a masonite panel may be absolutely smooth. Further texturing may be included in the "ground," or surface preparation of the support.

Paint quality refers to the handling of the

Figure 4.13
GREG SANCHEZ
The Path (compressed charcoal).
Courtesy of the student artist.

This beginning drawing student found repeated curvilinear elements to be rhythmical.

Figure 4.14
GREG SANCHEZ
Within Boxes (compressed charcoal and chalk).
Courtesy of the student artist.

Two basic themes appear in this work: simple curves and straight lines.

Figure 4.15
THOMAS GRIFFITH
Vera Cruz Palm (oil).
Collection of the artist.

A single palm best expresses my feelings about the breezy heat along the Gulf of Mexico.

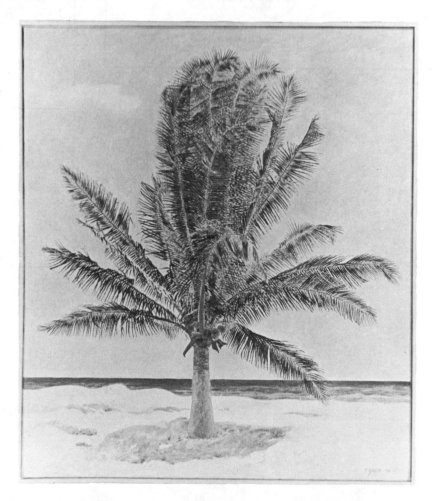

Figures 4.16A and B
Depending on where the boat is placed, it is either seagoing or a toy. Generally, images closer to the bottom of a painting in this format will appear to be nearer to the observer.

Figure 4.16A (above)

Figure 4.16B (right)

paint itself, producing different textures. Paint applied in thin washes, called "glazing," may have no texture at all, while oil or acrylic pigments in particular have the capacity to be applied thickly with the brush or a palette knife to achieve an effect called "impasto."

The *medium*, or chosen materials of the artist, such as oil, watercolor, or acrylic, are utilized for differing effects.

Figure 4.17
Textured support (canvas or watercolor paper), smooth support (sanded untempered masonite).

Figure 4.18
KEN MORROW
Still Life (detail) (acrylic).
Courtesy of the artist.

In acrylic, textures may be applied with a product called *modeling paste* (see Chapter Six) and glazed over with color washes (see Glossary).

SUGGESTED EXPERIENCES— introduction to composition

Since shape, value, and the interaction of space and volume are least familiar to beginning painters, the exercises in this section will stress those elements rather than line or texture.

Shape and Value—Two Dimensional

Suppose you are going to design a quilt or some fabric. The image that arises in your mind is probably not a landscape or a still life, but is instead a pattern of some sort. The painter must also be concerned about the arrangement of shapes, regardless of whether the painting is realistic or, like a quilt pattern, abstract.

(1) Start with the world you see—whether imagined or environmental—and translate it into a grouping of simple, flat shapes of about six values ranging from black to white. Regardless of your subject, reduce the grouping to variations of the three basic shapes, the square, triangle, and circle.

(2) Add two tubes of designer's gouache, white and black, to your supplies. Pronounced "guash," this water-based pigment can be mixed to a creamy consistency in the top of your watercolor set.

(3) After making several small sketches of your subject to determine the shape of your picture plane, with a ruler draw the desired rectangle on a sheet of your tablet. Filling the rectangle from border to border, create a value-shape arrangement of your subject. Note that since similar values form a bond, you can guide the eye through the composition by linking them.

(4) Some artists concentrate on shape by simply observing shadows on a wall and interpreting them in black and white.

Figure 4.19

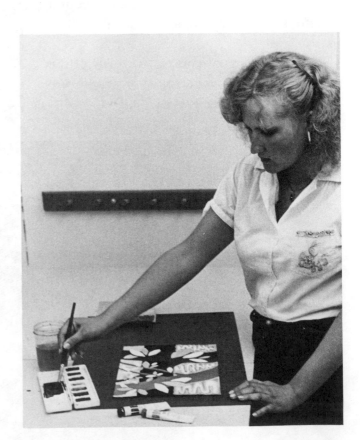

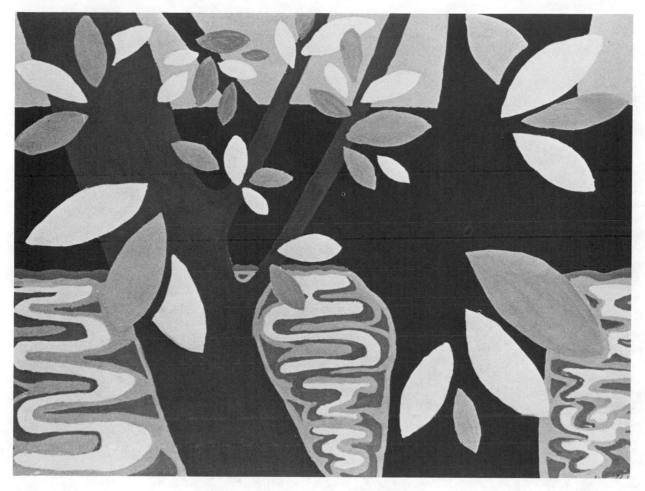

Figure 4.20
LISA NEFF
Organic Design (black-and-white gouche).
Courtesy of the student artist.

This work shows careful organization of the whole picture plane.

Volume and Space

One of the most puzzling aspects for the beginning painter is the problem of making things look "real." Earlier we noted how important the light source is to volume building.

(1) For this exercise, set up some simple volumes in a single light source, either from a lamp or a window. If the volumes enclose space or are hollow, such as walnut shells, so much the better. Use conté crayon or charcoal pencil to analyze light and shade.

(2) At the same time we must be aware of the validity of shape and value discussed in exercise 1. This exercise will be to move from your preliminary study to an interaction of space-volumes and shapes within the total rectangle. On a sheet of your tablet, describe the desired rectangular area in which you intend to work. Using your black and white gouaches, see how well you can fill the page with shapes of dark and light, while retaining a feeling for the volumes and spaces of your earlier efforts.

Compositions may or may not be as abstract as Figure 4.24. Figure 4.25 illustrates how space and volume may seem to be the

Figure 4.21
SALVATORE CASA
Silhouette at Dusk (opaque watercolor).
Courtesy of the artist.

Even though this painting has fine detail, it maintains simplicity.

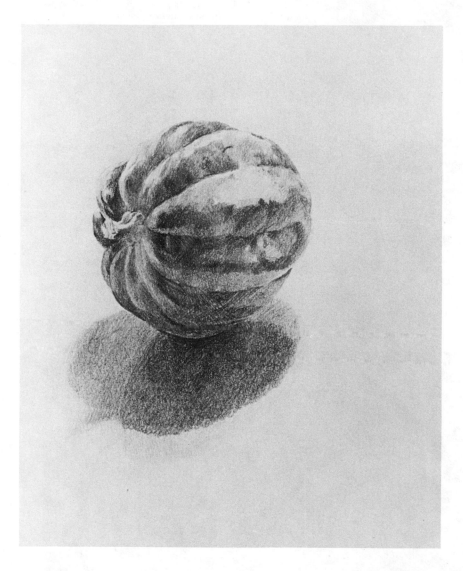

Figure 4.22
WAIF MULLINS
Acorn Squash (soft pencil).
Courtesy of the artist.

Light and shade give this squash the appearance of solidity.

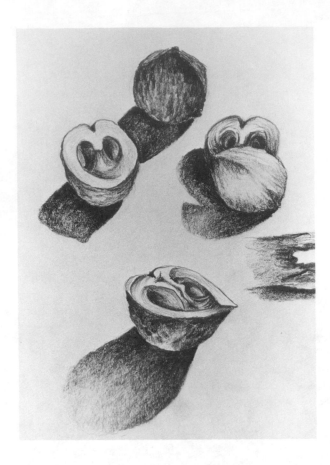

Figure 4.23 (left)
LISA NEFF
Study of Walnut Shells (charcoal pencil).
Courtesy of the student artist.

Not only solidity, but also enclosed space exists in these hollow shells.

Figure 4.24 (below)
LISA NEFF
Walnut Design (gouache).
Courtesy of the student artist.

This student artist has moved from the "study" to a full composition.

Figure 4.25 (opposite)
SCOTT HUDSON
Box and Feather (gouache on oatmeal paper).
Courtesy of the student artist.

The cubelike box surrounded by space was one of the objects of this work.

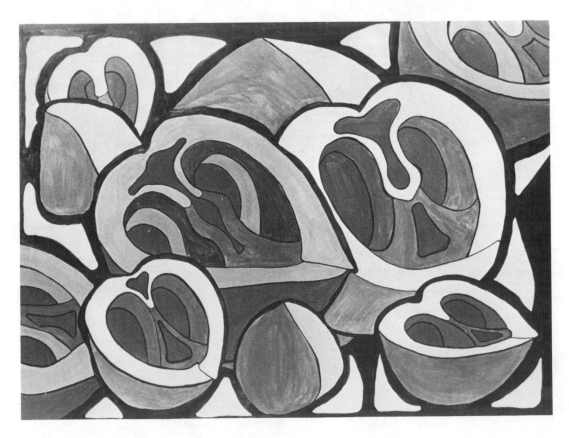

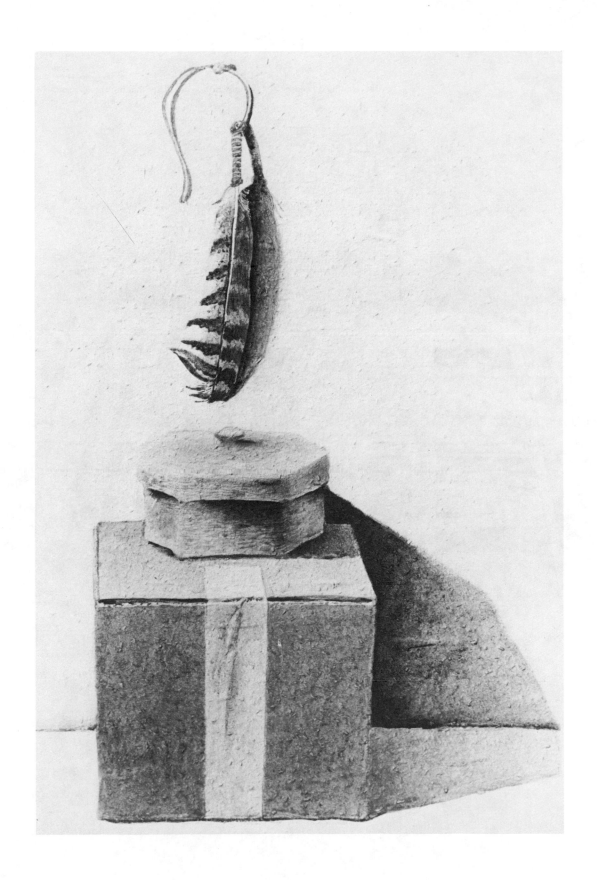

Figure 4.26
BRUCE VELDHUIZEN
Spaces (pencil).
Courtesy of the student artist.

Developing a "sense" for composition is aided by making the spaces between the objects the major interest.

major key to the composition, light still playing an important role.

Still another method of emphasizing space is by making the "background" areas of equal or even more importance than the central objects.

We are fortunate to live in an age when drawing and painting reproductions of high quality are readily available in libraries and book stores. Develop awareness. Train your eye to perceive how great artists build the marvelous harmonies that fill their work so joyfully.

VIBRANT AND ALIVE, color is one of the most captivating elements available to the artist. The frustrating struggle to mix or duplicate colors is greatly eased by a systematic approach to the palette. The palette refers not only to the surface upon which paint is mixed, but also to the choice and arrangement of pigments. With that in mind, let us take a direct route from the knowledge of what color is, to the specific tubes of paint we need to set up an efficient palette.

Of the various wavelengths of electromagnetic energy, approximately three percent exists as white light. This particular segment of energy is received by the eye and transmitted to the brain by way of the optic nerve.

A fascination for color led the midnine-

CHAPTER FIVE

Color and the palette

teenth-century Scottish physicist James Maxwell to the discovery of its basic structure. He found that there are three primary color wavelengths, which, when combined on a reflective surface, produce the following:

Red + blue = magenta.
Green + blue = cyan (blue-green).
Red + green = yellow.

By combining red, green, and blue, Maxwell produced white light (Plate 10). Modern technology utilizes this process of adding colors in two areas known to us all—color television and stage lighting. (If you have access to stage gels, place the three colors in empty slide frame mounts, and with the aid of three slide projectors you can produce your own "light show.")

Figure 5.1

Figure 5.2

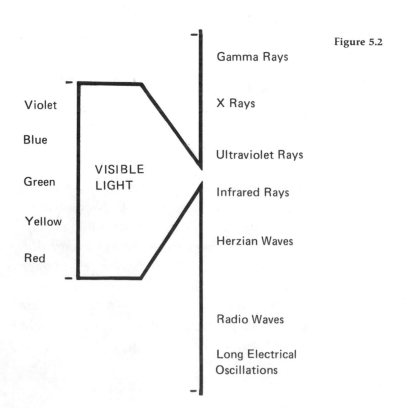

Violet

Blue

Green

Yellow

Red

VISIBLE LIGHT

Gamma Rays

X Rays

Ultraviolet Rays

Infrared Rays

Herzian Waves

Radio Waves

Long Electrical Oscillations

However, in everyday experience we begin with white light, either from sunlight or an electrical source. We see individual colors because surfaces absorb certain energy wavelengths while reflecting others. A white shirt, for example, reflects all of the energy in a balanced combination, while a black hat absorbs virtually all of the wavelengths. A purple bandana results from green energy being filtered out by the colored dye. This process of filtering (absorbing or reflecting parts of the total spectrum) is called *color subtraction.*

Another factor relating to color subtraction and of concern to the painter or printer is that the specific colors obtained through color addition—yellow, cyan, and magenta—now function as the "pigment primary" colors. These primary colors must be acquired in the form of paint, dye, or ink—only the manufacturer can make them (Plate 11).

So far, we have discussed one of the three aspects of color—hue, or the identification of its placement in the spectrum. The inner ring of the color wheel shown in Plate 12 demonstrates a second characteristic—intensity, or whether the hue is pure or dull. In Figure 5.4, we see the third trait of color—value, the lightness or darkness of hues.

Since in opaque painting the density of the pigment is such that the paint itself reflects the color, white and yellow can be used to lighten values. In transparent painting, the light penetrates the pigment, as it would cellophane, striking the white surface beneath and reflecting back through it. White paint is

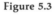

Figure 5.3

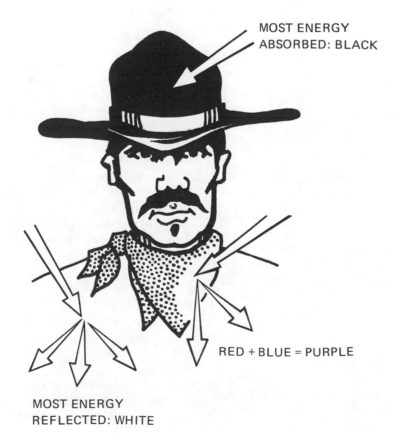

MOST ENERGY
ABSORBED: BLACK

RED + BLUE = PURPLE

MOST ENERGY
REFLECTED: WHITE

Figure 5.4
Note that yellow (lower right) is nearly white in terms of value, whereas blue (opposite) is much darker.

not used in this technique, hence the need to work from light to dark. In opaque painting, we may go back and forth—light pigment on dark or dark on light.

There are some additional definitions that are vital to effective color handling:

• Analogous colors are those that are close to each other in the spectrum. The result of mixing pure analogous colors is additional pure colors, that is, yellow + orange = yellow-orange of equal intensity.

• Complementary colors have no analogous ties whatsoever. Refer to Plate 12 and you will see that green is a mixture of cyan and yellow. Therefore, green can be classified as having no red (magenta), which is termed the complement. Likewise, orange is the complement of blue, and violet of yellow. The color wheel is simply the spectrum bent into a circular form. This system places the complements opposite each other. Complementary colors enhance each other when placed side by side, but will yield dull, neutral colors when mixed.

Colors may also be classified as warm or cool. The warmest place in the spectrum is vermilion red (fire-engine red) and the coolest is blue-green (water and ice). Colorists make use of the fact that each hue formation has the potential of being warm or cool.

Cool blue: blue-green. Warm blue: blue-violet.

Cool red: magenta. Warm red: vermilion.

Cool yellow: light and slightly green. Warm yellow: yellow-orange.

Just as the shift from major to minor key builds tension in music, juxtaposing warm and cool color variations does so in painting.

74

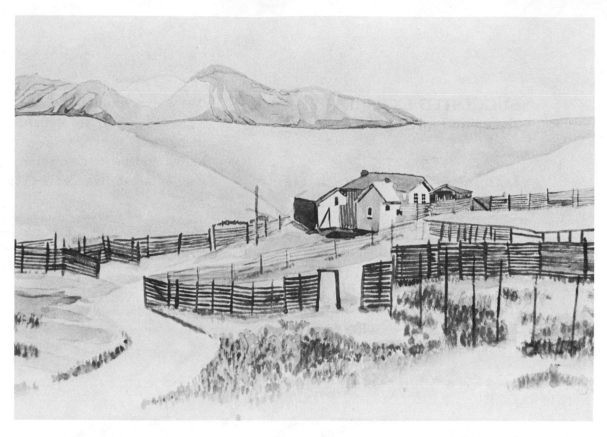

Figure 5.5A
WILLO GRIFFITH
The Farm (watercolor).
Courtesy of the student artist.

The clarity of this approach depended upon color-and-value decisions' being made prior to the painting's execution.

Figure 5 5B
ROBIN GRIFFITH
Flight (oil).
Courtesy of the student artist.

This painting is opaque, the use of white paint allowing the light areas to be done on darker pigment.

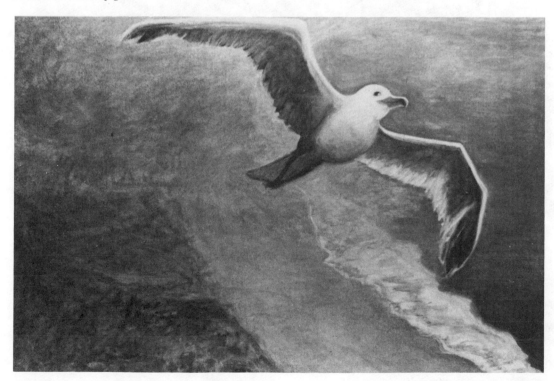

SUGGESTED EXPERIENCES—
seeing and mixing color

Learning to See Color in Nature

We have all seen the wonderful trees the first-grader does with crayons and poster paint—one brown trunk with a green lolli-pop top. The adult also has ways of seeing that are formed by habit. The first requisite of color handling is to wipe the slate clean—look at everything as though for the first time. Most of what we see in nature is not clearly identifiable as red, yellow, or blue, but is muted and neutral, so some clues to seeing their subtle differences are called for.

(1) First, don't stare at a color in your concentrated effort to discover its placement in the spectrum. Not only do the receptors in the eye fatigue, but all colors are relative to their surroundings. Ask yourself, "How does this tree trunk differ from those nearby?" Ask not only if it is darker or lighter, but "Is it more orange, violet, or green?" Refer to Plate 1 to see a sensitive response to those delicate changes. Again—see as though for the first time.

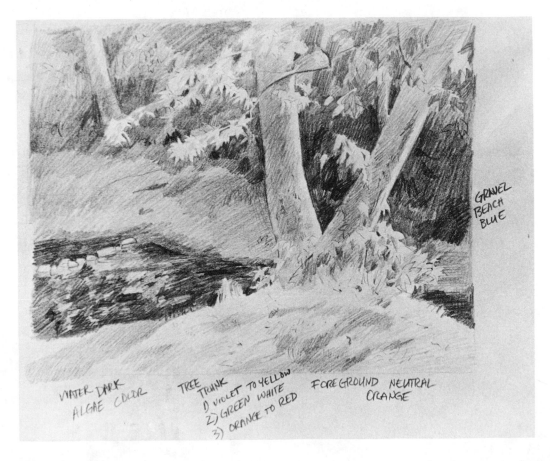

Figure 5.6
WAIF MULLINS
Sketchbook page (pencil).
Courtesy of the artist.

Reminder notes tell of subtle color differences.

Experiments with Mixing Colors

In the next chapter we deal with various painting media, but for the purpose of acquainting yourself with how color functions, you will need to add the three primary colors to your supply of designer's gouache—rose red, turquoise blue deep, and yellow light. You will continue to use white to make color tints (light colors), but eliminate black, since the primaries alone can produce dark colors (shades). A sheet of aluminum foil, a white plate, or a watercolor palette from an art store will provide ample mixing space.

(1) Remembering to mix the gouache to a creamy consistency, paint the three primaries at equidistant points on a sheet of your drawing paper. Then, making sure to keep the water and brush clean, particularly when changing to a new primary, work one hue toward another to produce a graded arrangement of intermediate colors.

(2) When you mix any two primaries, or any group of analogous colors, additional pure hues are the result. If, however, any amount of all three primaries is present, greys or browns—neutral colors—are produced.

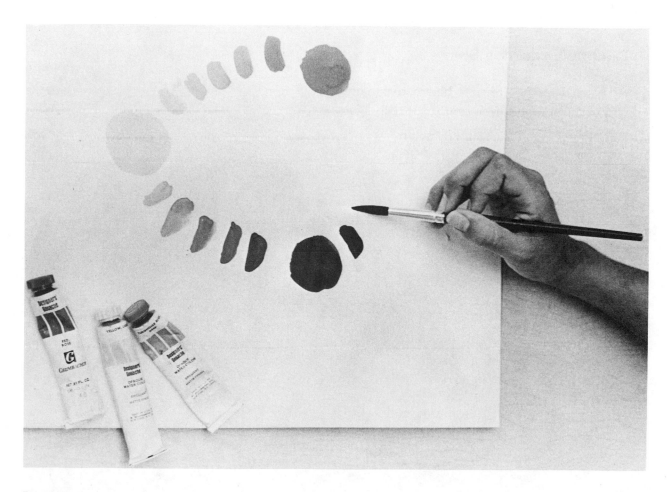

Figure 5.7
As long as you mix colors between two primaries, excluding the third, additional pure hues will result.

To mix neutral colors, as seen in the inner ring of the color wheel (Plate 12), you must start with each pure color, and add a little of the complement from the opposite side of the wheel or triangle. Make sure that the majority of pigment mixed is the parent color, so that the neutrals are readily identifiable with that part of the spectrum. Just as in Plate 12, place the neutral adjacent to the parent hue. Carefully mix all three primaries to reach a charcoal black, which may be placed in the very center. This exercise is very important in that it shows you that neutral colors have the potential of being just as rich and vital as the pure hues.

(3) Colors form family relationships according to how light or dark they are, as well as how intense or dull. Regardless of how many colors are used in an area, if they have those two qualities in common, they will relate. Using white and yellow to raise values to a range of tints, and complements for shades, place similar family groupings adjacent to each other to form a movement, or "gesture," across the page.

Painting Something Seen

All of us have the desire to be creative in one way or another, but frequently our daily lives are so busy that we postpone doing anything about it. After raising a family, the student represented in Figure 2.22 found the time to implement a long-cherished goal—learning to paint. She elected to experiment with transparent watercolor, using tube primaries rather than cake colors. If you consult the table on the next page, you will see that the primary colors in watercolor are rose madder, thalo blue, and cadmium yellow light. No white is used in transparent painting, which made it necessary for her to paint the light areas first and then progress to the darker colors. Her first paintings were done on a 15" by 20" watercolor pad.

Figure 5.8
LANI BASSLER
Cityscape (gouache).
Courtesy of the student artist.

Regardless of hue, colors of similar value or intensity will relate.

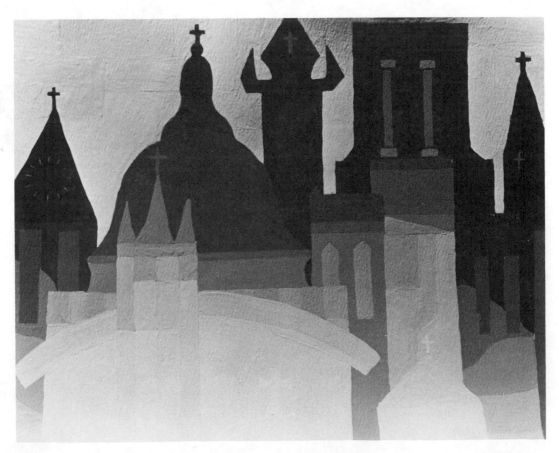

Watercolor Primary Range	Watercolor Intermediate Range
Cadmium yellow light	Cadmium yellow medium
Cadmium yellow pale	Cadmium orange
Thalo blue	Cadmium red light
Cerulean blue	Vermilion
Thalo crimson	Thalo green
Rose madder	Cobalt blue
	Ultramarine blue

Acrylic Primary Range	Acrylic Intermediate Range
Cadmium yellow light	Cadmium yellow medium
Thalo blue	Cadmium orange
Cerulean blue	Indo orange red
Manganese blue	Cadmium red light
Acra violet	Vermilion
Thalo crimson	Thalo green
	Cobalt blue
	Ultramarine blue

Oil Primary Range	Oil Intermediate Range
Cadmium yellow light	Cadmium yellow medium
Thalo blue	Cadmium orange
Cerulean blue	Cadmium red light
Manganese blue	Vermilion
Thalo red rose	Thalo green
Rose madder	Cobalt blue
	Ultramarine blue

Figure 5.9
Additional colors in the green, violet, or red range are available, but those
mentioned above are broad enough in range to provide a versatile palette. Since
white is used a good deal, it is economical to buy the pound tube.

Expanding the Palette

The manufacturer is able to produce a more intense range of intermediate colors than we, so for maximum flexibility it is time to add more pigments to the palette. The table in Figure 5.9 gives you the trade names for tubes of watercolor, acrylic, and oil paints.

To predict the results of mixing pigments, the palette should be laid out systematically. If it is organized as in Figure 5.10, you know that pigments mixed with those placed adjacently will yield full intensity colors. Also, by mixing pigments with those on the opposite side of the palette, neutral colors will result.

Some Added Notes

This discussion would not be complete without referring to two French masters—Monet and Bonnard—whose worlds centered on the expressive force of color. You would profit greatly by following several of their approaches to its use.

Monet was so enthralled by the fleeting changes of color and light that he was compelled to paint in series. The haystacks represented in Plate 13 are only two of many he painted of that particular subject. Water lilies, views of the Seine, rows of poplars—all were painted repeatedly in Monet's search for color nuances.

Bonnard constructed a range of analogous colors, and then by a process of "bridging," he moved around the spectrum until he reached the complement (Plate 14). If, for example, he chose a major "key" (or grouping) of analogous blues, by including green he moved toward yellow. Then, by adding colors in the orange family, he completed the steps to arrive at the complement, thereby enhancing the blue.

The concept of a major color key was also employed by the modern master, Matisse. The titles of his paintings reveal this tendency, such as *The Blue Window* or *The Red Studio*. Other colors were added sparingly.

Finally, two questions should be clari-

Figure 5.10
Keeping your colors close to the edge of the palette to allow for ample mixing space, start with white in a central position. Move in one direction with cadmium yellow light, cadmium orange, cadmium red light, and thalo red rose. On the other side of white, begin with thalo green, then cerulean blue, thalo blue, and ultramarine blue. You can see that this arrangement is the equivalent of an open-ended color wheel.

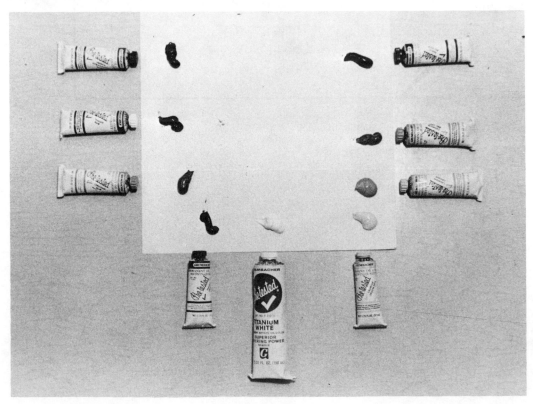

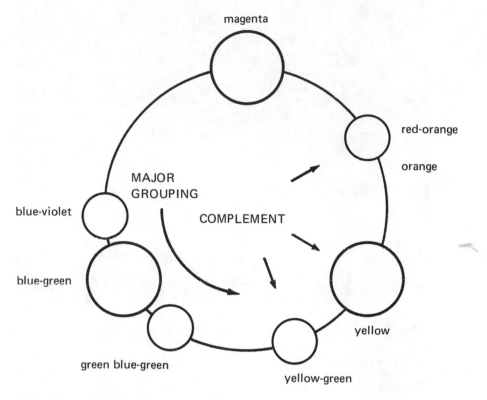

magenta

red-orange

orange

MAJOR
GROUPING

blue-violet

COMPLEMENT

blue-green

yellow

green blue-green

yellow-green

Figure 5.11
Color bridging.

fied for the beginning painter. First, the question frequently arises, "If I need more of a certain color, how do I mix it again?" It is true that exact duplication of colors is difficult, but here again, the importance of a uniformly arranged palette can be seen. You know at all times where each color is placed. A systematic approach will bring the fastest results.

The second question is, "How do I get my colors to be very dark or light without ending up with a huge amount of paint?" For very light colors, start with white or yellow and add the desired hues. Dark colors, including black, can be produced in various ways: by combining thalo or ultramarine blue with cadmium red light, by mixing thalo green and thalo rose red, or by a combination of all colors on the palette with the exception of white.

GOOD CRAFTSMANSHIP needs to be nurtured from the beginning if you are to bring out the best of your chosen medium. The bibliography includes publications which give in-depth information about materials and methods, but for our purposes this chapter concerns four basic media—watercolor, egg tempera, acrylic, and oil. They differ not in terms of the substances used to produce color, but in the binder, or vehicle in which pigment is contained.

Medium	Vehicle
(1) Watercolor	Gum arabic and glycerin
(2) Egg tempera	Egg yolk
(3) Acrylic	Water-base plastic
(4) Oil	Linseed oil

CHAPTER SIX

Putting color to work: the media

WATERCOLOR

As long as the paper is not overly absorbent (blotterlike) and if there is no oil content, it will accept watercolor. However, most watercolorists choose specially prepared watercolor paper of various kinds:

- Hot pressed paper—smooth, good for line or detail.
- Cold pressed paper—textured surface, allowing for color fluctuation as pigment settles into minute pools.
- Rough or not pressed papers—even more rugged in texture.

You have a choice of purchasing watercolor paper by the sheet or in block form. In

either case, it is classified by weight, thickness based on pounds per ream; 70- or 90-pound papers are adequate for a start, although most watercolorists prefer at least a 140-pound weight, which of course, is more expensive. A new addition to the supply list is the trade name T. H. Saunders, Bainbridge Hotpress, which comes complete with a backing board. Ask your local art supplier about this product. The American watercolorist Rex Brandt (Plate 16) recommends all-linen rag papers for best results and permanence. However, for beginning efforts, a 50 percent rag, 90-pound paper, such as manufactured by Fabriano, yields good results. "Rag" refers to the process of reducing linen (in Arches paper) or cotton (in Fabriano) to a pulp, which is then sized to control absorbency, and dried in sheets.

Due to its aqueous nature, watercolor should be done on a nearly flat surface rather than on a vertical easel. Watercolor paper can either be tacked or taped to a drawing board,

or if large, wet washes are to be used, the paper should be "stretched" to prevent undue buckling.

The steps for stretching paper are shown in Figures 6.2A and B.

Plate 15 is a quarter-sheet watercolor developed in small areas, making stretching unnecessary.

For painting supplies, the sizes 6 and 12 soft-hair watercolor brushes are adequate in most cases, but you may want to add a ¾-inch or 1-inch flat brush for broad washes. Oriental brushes are also available in a 2-inch or 3-inch flat style called Hake. A small sponge can be used for textures, and a paint rag helps keep an unruly drip under control.

Suggested Experiences— Watercolor Technique

One of the basic problems of handling transparent watercolor is learning to control proportionate amounts of water and pigment.

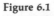

Figure 6.1

Figures 6.2A and B
(A) Soak the paper in a sink of water for about ten minutes, then drain off the excess. (B) Affix the paper to a drawing board with brown paper tape and allow to dry to a taut surface.

Figure 6.3

Both fluidity and adequate color intensity must be present. The following studio and field exercises will expand upon the initial experiences of the field trip in Chapter Three.

(1) Stretch a half sheet of watercolor paper on a board. Using a ruler, measure and mark the halfway point on the short length and divide the longer distance into thirds. Then apply masking tape between these points to produce six small painting areas. Each of the squares should be considered a space for experimentation with the following techniques:

- Wet into wet technique.
- The graded wash.
- Wet wash on dry paper.
- Sprinkled salt on wet wash.
- Mask out that resists wet pigment (may be removed when the paint is dry in the manner of rubber cement).

- By pinching excess water from the brush, the pigment adheres only to the bumps on the paper.

There is nothing so satisfying as the involvement that comes while working directly from nature. A watercolor that will always have meaning for me is one that recalls impressions of a specific occasion—the Bicentennial Fourth of July (Figure 6.5A). This act of communication has a deeper personal significance than the making of a "product."

The range of possible effects that can be achieved with watercolor is evident by comparing the paintings in Figure 6.4 with Plate 16 "wet into wet," Figure 6.5 "graded wash," Figure 6.6 "wet on dry paper," Plate 17 "salt treatment," Figure 6.7 "mask art resist," Figure 6.8 "dry brush."

Figure 6.4

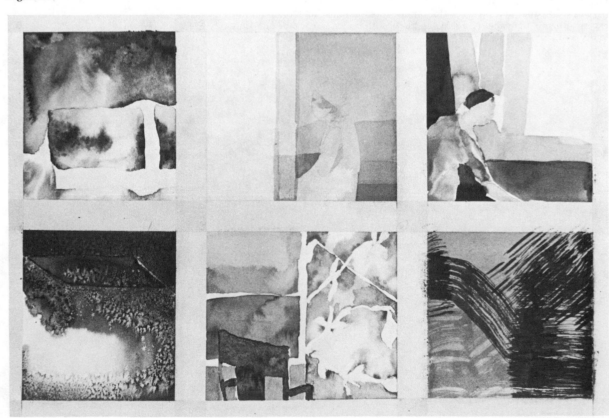

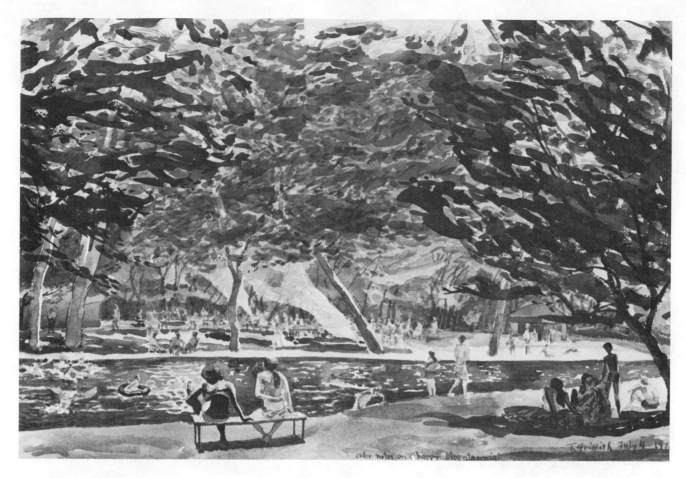

Figure 6.5A
THOMAS GRIFFITH
Bicentennial Fourth of July (watercolor, 21″ × 14½″).
Collection of Brenda Milbourn.

The small areas of pink or yellow were all painted first, and the surrounding green, blue, or dark colors last since the former must be applied to white paper for color clarity.

Figure 6.5B
ANN PIERCE
Olive Tree (watercolor, 21″ × 29″).
Collection of the artist.

Light washes were laid in over the top part of this picture, mask-out was applied in olive-leaf shapes, and then darker washes. The mask-out was then removed to reveal the original wash.

Figure 6.5C
JOHN AYERS
Stokesay Castle (watercolor, 22″ × 30″).
Collection of the artist.

Carefully graded washes were laid upon one another, each layer drying completely
prior to the next.

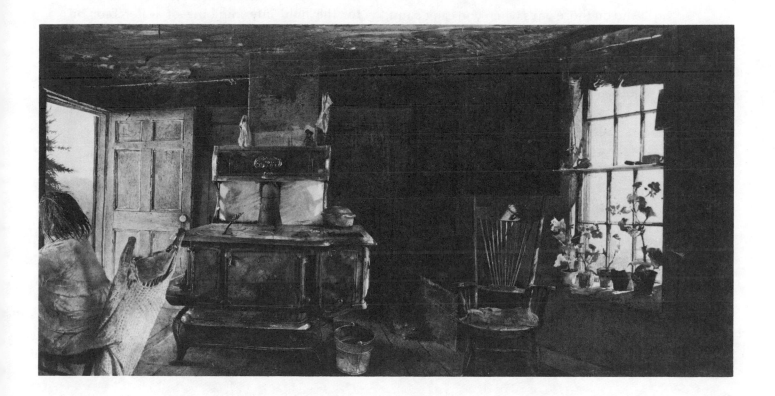

Figure 6.6
ANDREW WYETH
The Wood Stove (drybrush watercolor on paper, 23½″ × 34½″).
Farnsworth Museum Collection, Rockland, Maine; photograph by Paulus Leeser.

Drybrush allows the American master Andrew Wyeth to build rich color harmonies through the interaction of drybrush pigments with previous layers of paint.

(1) Stretch two quarter sheets or one half sheet of watercolor paper several hours before you intend to paint. Have plenty of water—even two containers to maintain color clarity. Use the recommended colors. Pigments in the tube instead of on the palette are like keys missing from the piano. Next, it is wise to make several thumbnail sketches to plan your campaign. You may block your subject with a pencil, but don't overdo the detail at this point. Lastly, employ the basic possibilities in Figure 6.7A, B, and C.

And on those days when you can't paint, you can learn a great deal by looking at the works of great watercolorists such as Winslow Homer (Plate 4). Fresh and vibrant, his works seem to have just been painted.

EGG TEMPERA

Egg yolk is an emulsion with both oil and water content that makes it a durable binder for pigment. Egg tempera paintings have a waxy luminosity somewhere between watercolor and oil. Its consistency does not allow for the fluid intermingling of watercolor or the heavy impasto of oil, but it is ideal for the meticulous handling of realist painters. Again, available in the bibliography are sources where you may find technical infor-

Figures 6.7A and B
(A) Wash in lightest colors, remembering that analogous relationships will yield pure colors when mixed or overlaid, whereas complements will neutralize—just as red cellophane placed on green will produce black. (B) Move to the middle range of values, still dealing with a wash concept rather than line or detail.

Figure 6.7C (above)
MAY AU MANION
Study of Fruit (watercolor).
Courtesy of the student artist.

Dark values, lines, textures, and drybrush were added last in order to pull the painting together.

Figure 6.8 (below)
SALVATORE CASA
Stephen's Perch (tempera on 300-lb. Arches paper).
Courtesy of the artist.

Although this artist has experimented with all forms of egg tempera, he has found the medium to be functional by using tube watercolors and well-supported 300-lb. Arches paper.

mation about painting recipes and techniques, but try introductory experiences that will require only your tube watercolors, an egg or two, and a sheet of smooth illustration board or 300-pound hot press watercolor paper.

Suggested Experiences— The Egg as a Binder

SUPPORT

Because of the requirement of a rigid support for the brittle tempera medium, painters use this technique on wood or untempered masonite panels. However, Figure 6.8 is an example of tempera on hot press paper, its flatness carefully maintained until framed and glassed.

PREPARING THE EGG MEDIUM

After cracking the egg, pour it back and forth between the two half shells to retain the yolk and remove the white, which is discarded. Dry the yolk by rolling it gently on a paper towel. After transferring it to the flattened palm on your hand, carefully raise it with thumb and forefinger of your other hand. Pierce the yolk with the point of a knife and drain the useable contents into a cup.

The rest is easy. Stirring slowly, combine the yolk with the cold water until it is a creamy consistency. This usually takes about 50 percent of each ingredient. Even when refrigerated, the yolk medium will keep only a few days, but a few drops of vinegar or oil of cloves will extend its life.

PAINTING IN EGG TEMPERA

Most tempera painters prefer to mix pure pigments with water to form a paste that is added to the yolk medium. A perfectly ac-

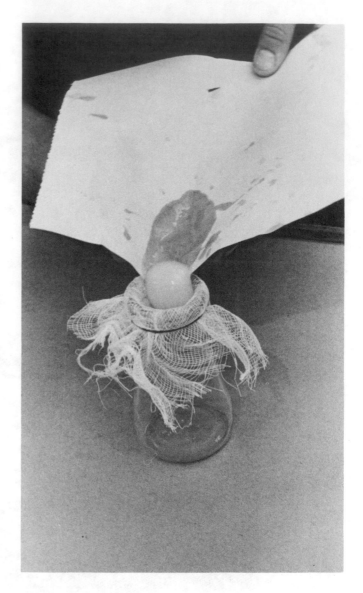

Figure 6.9
For best results in the removal of egg white, many tempera painters strain the yolk through cheesecloth.

ceptable substitute is the method of using the egg medium with tube watercolors. You will need two containers in addition to the brushes, palette, and paper: one for water to clean brushes, the other for the yolk medium. The 300-pound hot press paper need not be stretched, but make sure it is kept flat. Try the basic techniques of tempera handling in Figure 6.10.

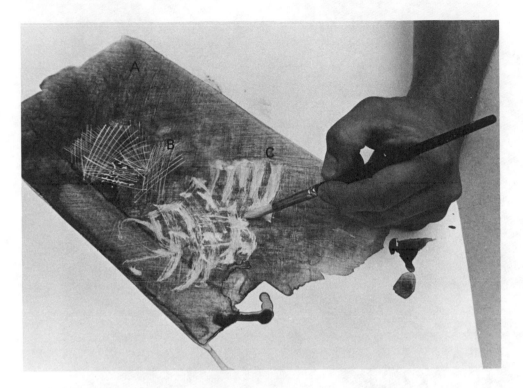

Figure 6.10
(A) Wash. Similar to watercolor technique, tempera can be washed onto the
surface in a wet manner. (B) Crosshatch. This is where tempera's strength lies;
it is particularly suited to minute brushwork. (C) Scumbling. Scrubbing loosely
on pigment allows earlier applicatons of color to show through.

ACRYLIC

Acrylic paints have advantages and disad-
vantages. The advantages are:

1. Technically they are very sound because the
acrylic resin becomes an insoluble, flexible binder
that surrounds the paint molecules. Successive
layers may be applied regardless of whether the
pigment has been diluted with water or medium.
Acrylic medium contains the same resin as pig-
ment and can be mixed with paint for a translu-
cent glaze, or used as a final picture varnish. Simi-
lar in appearance to white glue, it dries to a tough,
flexible, transparent film. Of the two available
types, gloss (shiny) and matte (nonshiny), the lat-
ter should not be used as a final varnish without
adding some gloss medium, or the color intensity
becomes clouded.

2. If not too slick or oily, any ground is ac-
ceptable for acrylic. Best is the very white ground
with the trade name of acrylic gesso, containing
the same resin as the paint.

3. They are versatile in that they can be treated
as watercolor, be given the impasto of oil paint, or
approached from the meticulous standpoint of
egg tempera.

The disadvantages of acrylics are:

1. They are fast drying, and therefore do not
have the long-term maneuverability of oil paint.
Once dry, they cannot be restored to a fluid state,
as can watercolor.

2. When used in the manner of transparent
watercolor, the plastic base does not allow for the
same fluid intermingling of colors that occurs with
pigment and gum arabic.

Figure 6.11
STEVEN POLKINGHORNE
Late Afternoon (acrylic).
Collection of Kaiser Hospital.

This artist has found acrylic to be an acceptable substitute for egg tempera, a medium in which he has also worked.

Figure 6.12A
CRAIG RASMUSSEN
The End of the Alphabet (acrylic).
Collection of California State Univeristy, Chico.

Using gloss medium with pigment, even the most opaque colors, such as white yellow, were applied in a translucent glaze.

Figure 6.12B
RUTH ORMEROD
Still Life (watercolor and acrylic on a gesso panel).
Collection of Frank Ficarra.

In this case, the artist wanted to retain the fluidity of watercolor with the durability of acrylic. By adding ¼ gloss medium to the paint water, and a final varnish with the mixture, the watercolor did not need to be glassed.

The following acrylic supplies are recommended:

1. Brushes. Watercolor brushes work well when the paint is thinned with water; nylon bristle brushes are designed for heavier pigment use. Even better is the recently developed multimedia brush, good for watercolor, acrylic, or oil paints. All brushes should be washed thoroughly after use, especially when the bristles have been saturated with plastic-based acrylic pigments.

2. The palette. Any white, nonabsorbent surface, such as a plastic watercolor palette, will work nicely for mixing colors. The essential need is for adequate space to combine pigments. If acrylic paint dries on the palette, it can be removed by scraping with a knife after a warm water soak. For those with limited time, there are disposable paper palettes, as well as the ever-useful aluminum foil.

3. Additional acrylic products. Other acrylic painting aids are available. Gel medium is viscous and glossy and can be applied with a brush or palette knife for an impasto. Modeling paste contains marble dust, and produces even heavier textures.

Suggested Experiences— Uniquely Acrylic

You are familiar with canvas, paper, or panel supports for painting, and indeed acrylic can be applied successfully to all of them by the use of brush, palette knife, or airbrush. However, acrylic is capable of a new concept in picture making—it can be its own support.

(1) On an approximately 20-inch square smooth surface, such as glass or formica, pour three or four tablespoons of matte *medium. Rotate the surface on a slight angle to allow the pool to spread to a uniform thickness.*

95

Figure 6.13
Acrylic supplies include erminite multimedia brushes, pigments, gloss and matte mediums, modeling paste, and get medium. Just as with watercolor, a canteen is a useful water container. Included in this group of supplies is a product called Artist's Palette Seal by Masterson Enterprises, Inc., an airtight plastic container.

Figure 6.14
STEPHEN WILSON
Eclipse (airbrush acrylic on paper).
Courtesy of the artist.

Subtly graded tones can be achieved by applying the pigment in a fine spray with the airbrush.

Figure 6.15

Keeping the surface flat, allow to dry; according to weather conditions, it should take about eight hours.

Using a sharp knife, carefully lift an inch or two of one edge and peel off the acrylic skin. Don't allow the slick underside to become entangled or it will stick to itself. These sheets can be stored between pieces of paper.

The acrylic sheets can be trimmed with scissors for straight edges, and readhered adjacently by applying the slick side to a window, which now becomes an "easel." The small pieces can be joined to create any shape or size by brushing the meeting edges with matte medium. If you prefer to work flat, glass backed with white paper or white formica will reflect light well.

(2) When color effects are desired, either with pigment or by laminating flat shapes such as dried, pressed flowers or butterfly wings within the layers, gloss medium should be used. When textures or patterns are made with twine, fabric shreds, or feathers, the laminating may be done with matte medium. When laminating, the shape or texture being applied must be saturated with medium on both sides.

(3) Another source for patterns or colors that may be laminated can be found in magazines. Brush four liberal coats of gloss medium on the photograph or decorative material in the magazine, allowing about half an hour drying time between applications. When the surface has become clear and dry, soak the page in water for about five minutes. Place the page face down on a table or sink counter and remove the paper by peeling or scraping with a pot scrubber. When all the paper is removed, you will have an acrylic transparency of the image that may be incorporated into your design.

Figure 6.16

Figure 6.17

Figure 6.18

Displaying the finished work has one requirement—back lighting, either from a window, an electric source, or as with transparent watercolor, light reflecting through the acrylic from a white surface. Following are two suggestions:

1. Consider a window you may have that provides necessary light, but for reasons of privacy or a less than inspiring view needs to be curtained. The acrylic picture may be peeled off and readhered to clean glass according to your needs. Also, a border may be painted around the edge with dark pigment to give a finished look.

2. When hung as a free-form curtain, care must be taken not to allow two areas of the slick surface to come in contact and become adhered. This can be prevented by rubbing the surface with a cotton wad dipped in talcum powder.

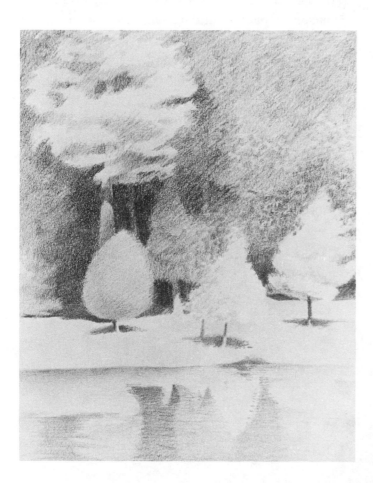

Figure 6.19A
KAREN RIDDARPANG
De Sabla (conté crayon).
Courtesy of the artist.

Although this artist delights in the confrontation with nature . . .

Figure 6.19B
KAREN RIDDARPANG
Luminosity (acrylic lamination on glass).
Courtesy of the artist.

. . . experimentation with new forms is also a challenge.

PAINTING IN OIL

Oil painting has advantages and disadvantages. The advantages of oil painting are:

1. Rich color can be achieved either by glazing transparent washes one upon another or by applying the pigment densely for an impasto.

2. Because it is slow drying, time is less critical than it is with acrylic. If necessary, it can even be removed with paint thinner or turpentine at the end of a work session.

3. Its linseed oil base makes for unique handling.

The disadvantages of oil painting are:

1. If proper procedures are not followed, the layers of pigment will have little permanence and cracking or peeling will result.

2. For some, extended use of turpentine or paint thinner can be bothersome.

Oil-Painting Procedures

THE SUPPORT

Any dry, not overly flexible surface can be used if prepared correctly. Paper, wood or masonite panels, and canvas are the most frequently used supports. Their preparation is not only for relative permanence, but to protect the support from the deteriorating effects of the oil itself.

Canvas board is simply cardboard covered with canvas. An extra coat of acrylic

Figure 6.20

gesso (discussed in the next section) gives the surface a better "feeling" for brush work. Untempered masonite is a wood pulp panel, which when sanded and painted with acrylic gesso makes a solid support for egg tempera, acrylic, or oil. After applying several coats of gesso, the surface can be sanded until completely smooth.

Canvas has been a favorite of painters for centuries. Its quality varies from light to heavy jute or cotton to the most desirable linen canvas. By "stretching" canvas on a wooden frame (composed of stretcher bars), a flexible, responsive surface is attained. Stretcher bars may be purchased by length from an art store, or if tools are available they can be mitered and assembled from 1" x 2" pine strips. To stretch canvas, complete the following steps:

1. Assemble the slot and groove ends of the bars and adjust the rectangle with a true door frame or carpenter's square.

2. After checking to make sure that the fabric weave is on the same horizontal and vertical axis as the assembled bars, cut it to allow for 1½ inches extra on each of the four sides. If you are using raw canvas from a department store or surplus outlet, simply lay it on a table and place the stretcher frame on it. If your canvas is already prepared (called sizing and priming, covered in the next section), make sure the primed surface is face down. Using number 6 carpet tacks or a staple gun, attach one side to the center of the outer, narrow edge of a stretcher bar.

Figure 6.21A

Figure 6.21B

3. Move the frame to an upright position and attach the canvas directly opposite. If you are unable to pull the canvas so taut that a fold runs between the two points, canvas pliers are most helpful. Important: Do not stretch unprimed canvas too tightly because applying the gesso ground causes shrinking. Pull the third side of the canvas so that the center fold is somewhat dissipated, but the weave is not pulled off center. Again, attach in the middle of the bar. Do likewise on the fourth side.

4. Pulling toward the corner of the frame and then across, place a staple or tack 2 inches to the right and left of the center attachment. Repeat this on the other three sides so that you are progressing toward all four corners at the same rate. Continue the process until the canvas is completely stretched. When using tacks, avoid hammering them completely in, in case there is slackness that cannot be adjusted by inserting stretcher pegs in the corner slots. Eight of these pegs should be supplied free with the stretcher bars. Use the "hospital tuck" to finish the corners. With a razor blade or mat knife, trim the excess canvas to be flush with the stretcher bar. If the canvas is satisfactorily taut, complete hammering in the tacks or any loose staples.

Figure 6.21C

Figure 6.21D

THE GROUND

The traditional processes of sizing (isolating the canvas from the oil, which in time would rot it) and priming (coating the surface with a reflective white layer) are covered in many texts. However, for our purposes acrylic polymer gesso provides a good white ground in a single procedure. On unprimed canvas, apply the gesso liberally, starting in the center for even tension in the shrinking process. Cover the entire surface, brushing in both directions of the weave. In several hours the gesso should be dry, and a second coat can be applied. When the second coat is dry, sand the surface lightly. A coat of acrylic gesso should also be applied to student-grade primed canvas.

SUPPLIES

Refer to Chapter Five for the trade names of a basic supply of oil pigments. All of the recommended paints have high marks for permanence.

Figure 6.22

Figure 6.23

Thinning agents for oil paints are varied. Structurally, the ideal mixture is pigment ground in linseed oil just as it comes from the tube. From that point on, each additional ingredient tends either to weaken the molecular structure or darken colors as they age. Your basic supplies should include:

- Turpentine or mineral spirits.
- Sun-thickened linseed oil or stand oil.
- Damar varnish.
- Retouch varnish.

The use of these materials is discussed later in this chapter. A nonabsorbent white surface or a disposable paper palette needs to be organized so that there is plenty of mixing room (see Chapter Five).

Bristle brushes are used for handling thick paint or washing in broad areas of pigment. For thinned paint or developing detail, the oil painting sable brush is useful. You do not need many brushes in order to get started, but you do need: sizes 6 and 12 "flat" bristle brushes, and two sable brushes, size 8 in both "round" and "flat" types. Additional sizes, the lower the number the smaller the brush, may be purchased when you want a broader range.

Of the various types of palette knives in use, the most practical has a bent shank, allowing for better control. The easiest way to mix paint is simply to combine colors on the palette with a brush. The palette knife comes in handy, however, for removing excess paint from either the painting surface or the palette. Not to be ignored is the potential for applying pigment with the knife as well, as did landscape master Courbet. Two bottles with tops are needed for storing the brush-cleaning solvent, as well as the mixture (medium) for thinning paint.

To prevent glare from light falling on wet pigment, illumination should come from a source not directly aimed at the painting. Because of this factor, the vertical easel is most commonly used. Two types are available: the sturdy indoor easel, usually constructed of wood, and the lightweight aluminum variety for work in the field.

Finally, you should have a good supply of soft, absorbent paint rags for cleanup.

Suggested Experiences— Oil-Painting Technique

There are two basic approaches to oil painting:

1. Direct painting, called alla prima, is the method employed when the pigment itself is thick enough to reflect the desired color. One reason artists have been drawn to the medium of oil paint is because of the rich, tactile quality of the pigment itself.

2. Glazing is the laying on of pigment that has been thinned with oil painting medium. The transparent quality of this technique brings a freshness and luminosity as light penetrates and reflects through the paint layers.

Now it is time to get involved with some exercises. First, however, you must know how to develop oil paint layers. "Lean to fat" is a term that describes the process to be followed in the development of oil paint layers. You have seen photographs of mud flats fissured with innumerable cracks caused by shrinkage of the dry surface layers while the mud below remains wet. This also happens with oil paint if the top layers are thin (lean) and lower layers have greater oil content (fat). There are many recipes for painting mediums, but the simplest is to mix increasing amounts of sun-thickened linseed or stand oil to the solvent as follows:

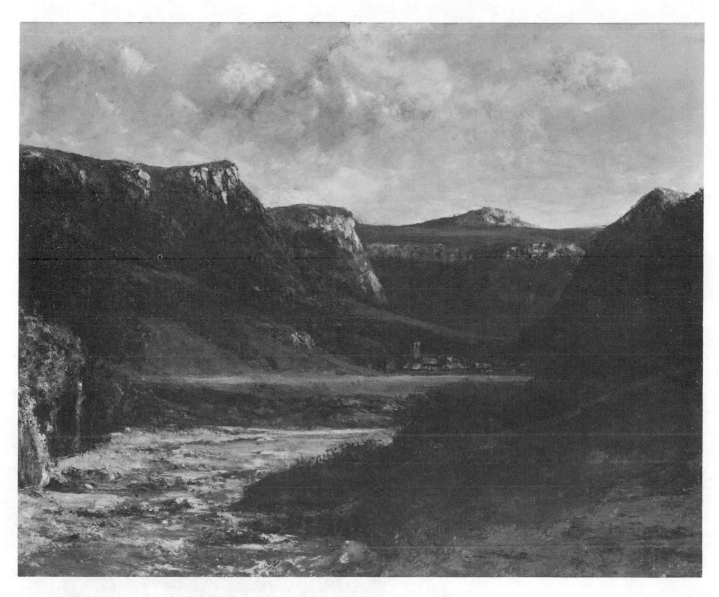

Figure 6.24
GUSTAVE COURBET
Landscape in Jura (oil).
Permission of the Fine Arts Museums, San Francisco.

For solid textures, Courbet used the palette knife, reserving brushwork for subtleties and detail.

Figure 6.25

Figure 6.26
THOMAS GRIFFITH
Spring Thaw (oil).
Collection of Gus Biebert.

Two examples of transparent glazing with ⅔ turpentine, ⅓ linseed oil medium as the dilutant are this painting and *Vera Cruz Palm* (Figure 4.15). Just as with transparent watercolor, the white gesso ground is the light reflector, no white paint being used.

- Laying in primary washes—straight turpentine.
- Second layers of paint—⅛ oil to ⅞ turpentine.
- Third layers of paint—¼ oil to ¾ turpentine.
- Final layers of paint—⅓ oil to ⅔ turpentine.

Optional is the adding of small amounts of damar varnish to the medium used for the final layers, which toughens the surface as well as providing color luster.

(1) After choosing a subject that is familiar to you and not overly complicated, here is a way to get the feeling for oil paint prior to committing yourself to a stretched canvas. Place a sheet of drawing paper on a board and tape wax paper over the reflective white surface. With such an inexpensive ground, you may try a variety of techniques:

Thin the pigment with turpentine, and just as if working with watercolor, block in your composition with free-flowing brushwork. Be exploratory and don't fear the results—all it takes is a paper towel to remove the paint. An even simpler method is to oil sketch directly on a disposable palette.

After 24 hours, the painting will be dry, and you may either scumble (brush over the surface, allowing the lower layers to show through) or add lines and textures for further definition.

(2) You have now determined whether your composition will be best adapted to a vertical, horizontal, or square-shaped canvas. You may feel easier about progressing if you block in basic shapes on the picture plane with a pencil or charcoal, and then spray with fixative. Just as before, turpentine alone may be used as a dilutant for the initial washing in of colors.

(3) You now have a choice: leave the painting with a feeling of free brushwork, perhaps adding some defining touches, or pursue realistic detail with sable brushes.

Points to Remember

Keeping in mind "lean to fat," continue to increase linseed oil content slightly as the paint grows thicker. As mentioned earlier, damar varnish may be added to the concluding medium, but it is not really necessary.

Figure 6.27
ARNELLE HUNT
One of 12 quick studies (oil on a disposable palette).
Courtesy of the student artist.

Such studies aid the student in choosing a suitable canvas for the final composition.

Another option is to spray the painting with retouch varnish (damar in a solvent) several days after completing it. To prevent too heavy a buildup in any particular area, the spray should be applied with a continual arm movement at about 12 inches distance. By catching a glare on the painting surface, you can see where the colors have a slight gloss after being coated with the varnish. Best for this purpose are synthetic, nonyellowing products such as Crystal Clear or Univar. The

Figure 6.28A
NORMAN MALLORY
Single Apricot (watercolor).
Courtesy of the artist.

The use of the sable brush led this artist into the exploration of combining
drawing and painting, as can be seen on the apricot with its crosshatch technique.

final varnish not only protects the surface, but revitalizes color and value as well.

One other thing needs to be said about painting media. Twentieth-century artists have become very resourceful about experimenting with a variety of materials. The combining of many techniques has given rise to a new term to describe the direction— *mixed media.* For that reason, some information about that approach is included in the Appendix, concerning painting on irregular or unusual surfaces. The Appendix is designed to assist you in developing a personal creative vocabulary.

The relationship between the practical use of technique and human creative growth can be summed up in the work of a former student who had a particular problem with painting brushwork. After struggling for several years to overcome a clumsiness in his handling of detail, he changed from an exclusive use of bristle brushes to sable. A complete transformation took place, not only in the final product, but in his sense of accomplishment as well. And this is how the process works. You think you may have reached a dead end, but with continued experimentation, the key twists in the lock and the door swings open!

Figure 6.28B
NORMAN MALLORY
Coat (egg tempera on gesso).
Courtesy of the artist.

Once the sable brush became part of Mallory's equipment, egg tempera was soon to follow.

Perspective

LINEAR PERSPECTIVE

Early in the fifteenth century, the great Florentine architect Filippo Brunelleschi made a discovery that was to change the course of Western art. Prior to his invention of what was to be called linear perspective, attempts by artists to create a convincingly "real" world were hit-and-miss. Brunelleschi based his new theory on these factors:

1. The picture plane must be organized in such a way that we, the onlookers, must see all portions of a painting from a single point of view. Earlier paintings were so constructed that it would have been necessary for us to bob up, down, and sideways in space in order to have a consistent impression of the world around us.

2. If you look down a railway, the tracks appear to meet in the distance. If carried far enough, all parallel straight lines that recede from you will seem to come together at what is called a "vanishing point." Further, if the parallel lines are horizontal, the vanishing point will always be on

110

A creative art vocabulary

the horizon line, or "eye level." The horizon line tells us if we are above, below, or on an even plane with the observed subject. Regardless of how many parallel lines recede from you, they will always have a *single vanishing point*. The essential problems are *knowing where your eye level exists* and then, *determining which lines in your composition are parallel.*

3. If there are two sets of parallels, we are dealing with two-point perspective.

4. When nonhorizontal lines recede, they appear to meet according to their direction in space, regardless of the eye level line.

5. As lines receding from us appear to draw together, we see that the spaces between them also reduce in scale. Diagonals drawn between a measured space between lines to the vanishing point automatically provide the correct reduction. Say for example, that you want to find the "perspective center" of a wall (see Figure A.5):

Similar to this technique is the method used to determine perspective spaces between such regularly placed items as telephone poles.

6. To visualize the drawing of circular objects, hold a bowl in front of you at arm's length. You will note that when the top of the bowl is at eye

Figure A.1
No single point of view.

Figure A.2
One-point perspective.

Figure A.3
Two-point perspective.

Figure A.4
THOMAS GRIFFITH
Pears (oil).
Collection of Norman Mallory.

Balsa strips on this painting indicate: (A) one set of receding parallels going to an eye-level vanishing point, and (B) second set of receding parallels with their eye-level vanishing point. The receding table legs (C) are vertical and therefore have a third vanishing point, which is not on eye level.

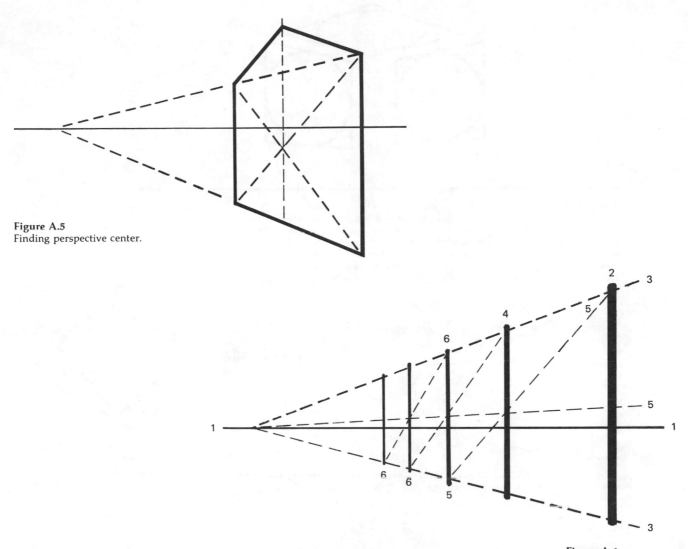

Figure A.5
Finding perspective center.

Figure A.6
Follow these steps: (1) Determine eye level. (2) Place your first pole to determine its size. (3) Since the poles are to be the same height, but are receding from you, lines to the vanishing point will regulate their "perspective size." (4) The second pole may be placed between the vanishing-point lines at your discretion. (5) Find the midway point of the height of pole 1, and draw a line to the vanishing point. By placing a diagonal from the top of pole 1 through the intersection of midway point of pole 2, the place where the line strikes the lower vanishing-point line is where pole 3 should be placed. (6) Continue this procedure for each pole, making sure *not to confuse the midway-height line with the eye-level line.*

level, you see nothing of the inside. By lowering the bowl a slender ellipse appears, which grows increasingly wider. Here, too, is a perspective technique that will assist you (see Figure A.7).

7. Unless you decide to delve into perspective from a technical standpoint, a commonsense approach will serve for most painting problems, such as the placing of vanishing points along the eye level line. While holding a box in front of you at arm's length, rotate it back and forth. You will see less of one side as you see more of the other. So remember that as the vanishing point draws closer to one side of the object, its counterpart moves in the opposite direction, most likely off the picture plane entirely.

8. When anatomical or irregularly shaped forms such as trees recede, scale reduction is called *foreshortening.* Here the guidelines are less formalized than when dealing with parallel lines.

Follow the steps taken by a beginning student in her first attempt to use perspective in a painting (Plate 18).

113

Figure A.7

Circular shapes, such as a wheel, may also be receding from you: (1) Draw a square in two-point perspective. (2) By the use of diagonals, find perspective center. (3) Mark the top, bottom, and sides by drawing a vertical through the center and a line to the vanishing point through the center as well. (If the circle were horizontal, such as a manhole cover, a line would go through the center to *each vanishing point*.) (4) Draw the ellipse so that it touches the four edge points.

Figure A.8

The more you see of one surface, the less you see of the other.

Figure A.9

THOMAS GRIFFITH
Life Study (conté crayon).
Collection of the artist.

When irregular forms, such as tree branches or anatomical subjects, are near or far, perspective is referred to as *foreshortening*.

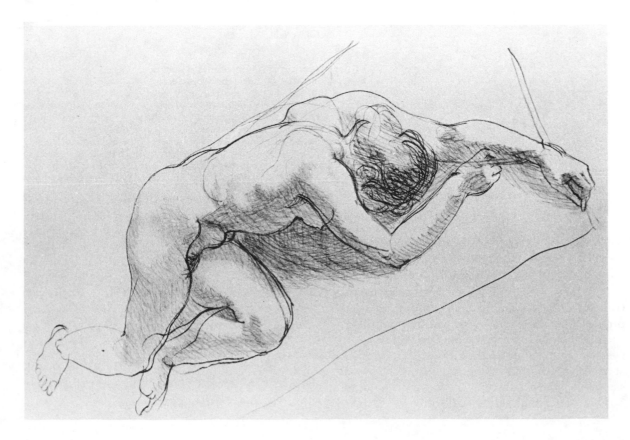

1. View the subject through a slide mount to determine the angle differences between receding parallels and the edges of the frame.

2. Don't forget the thumbnail sketch. This will aid in your choice of the canvas shape.

3. Know your eye level.

4. After blocking in guidelines lightly with a pencil, spray with charcoal fixative and proceed according to the recommendations in Chapter Six.

AERIAL PERSPECTIVE

If linear perspective provides a framework to structure the visual experience on the picture plane, aerial perspective is concerned with creating an "airy" spaciousness through an atmospheric handling of color and light.

Coupled with atmospheric light is the role played by shadows in painting composi-

tions. The strength of presence of Rick Balch's cabbage (Figure A.11) is enhanced by his sensitivity to light and shade.

Matting and Framing

MATTING

Drawings and watercolors need to be framed and glassed to protect the fragile paper. Prior to framing, the picture area is strengthened by mounting your work behind a cardboard frame, called a mat. Mats are available in white, black, and a variety of colors. Although frame shops have the expertise to choose suitable mats or frames for

Figure A.10
THOMAS GRIFFITH
North Valley (oil).
Collection of Frank and Patricia Gladen.

One of the major motivations for this painting was space.

Figure A.11
RICHARD BALCH
Cabbage (oil, 20″ × 24″).
Courtesy of the artist.

Even the shadows on the cabbage are suffused with light, giving emphasis not only to the leaves, but the spaces between them as well.

your pictures, you may want to develop some skills for yourself. You will need these materials:

- Pencil and eraser.
- Mat knife.
- Mat board.
- Metal-edged straightedge or T-square.
- Paper tape.
- Chip board.

Now, follow these steps:

1. Measure the dimensions of your picture. If you do not intend to "crop" the painting to a smaller size, plan the inner aperture to be ¼ inch smaller than the picture on all four sides.

2. To this, add 3 inches on both sides and the top of the mat. For a better feeling of balance, the bottom width should be 3½ inches.

3. Lay the mat on heavy cardboard and cut the outer dimensions. Measure in from the edges and mark the front surface of the mat lightly with a pencil at the aperture corners.

4. Being very careful not to overshoot the corners, make each cut several times to insure that the blade has gone cleanly through. To insure that an error does not damage the mat, the straightedge should be laid on the final mat surface rather than the inner window.

5. Cut a piece of chip board so that it is ⅛ inch smaller than the outer dimensions of the mat. Lay the two sheets adjacently so that they meet snugly at the top edge of the mat. Make sure the mat is *face down*. After wetting the gummed edge of the

Figure A.12
Three mat knives are shown here—the ones on the left are standard. The one on the right is the Dexter mat knife with two settings: vertical for cutting outer edges, and slanted for cutting a beveled window to enhance the inner edges.

Figure A.13

Figure A.14

Figure A.15

Figure A.16A

tape by hastily pulling it through a small bowl of water, secure the mat and backing. When dry, fold to form a paper hinge.

If you are unable to glass and frame the matted work, an effective temporary protection is clear acetate (thicker than the plastic wrap available in grocery stores). Lay the picture face down on the acetate and cut the sheet so that it is several inches wider than the mat on all sides. This can be folded over the back and adhered with plastic tape. A hanger can be formed by running wire or string between two glue-on hooks anchored to the backing.

FRAMING

Frames should enhance rather than compete with paintings. For that reason, simplicity is advised.

To frame a canvas, the easiest method is to trim the canvas neatly and paint the outer edge with a color that is compatible with the painting. Next in simplicity is the lattice strip frame, seen on *Vera Cruz Palm* (Figure 4.15). The 1¾-inch lattice was nailed directly to the stretcher bars, and the corners puttied and sanded. The sides were painted a light grey and the leading edge an off-white. Greys or soft whites will work with any colors.

More expensive but sympathetic with any color scheme is the metal strip frame, available in silver, gold, and mahogany. You can save some money by ordering the metal strips to your own specifications and assembling them yourself. Such a mail order house is ASF Sales, P.O. Box 6026, Toledo, Ohio 43614. Assembly instructions are included, and the only other items you would need are a screwdriver and picture wire.

To frame a glassed work, use the above instructions. The metal strip frames are also available for narrower matted pieces.

Figure A.16B
THOMAS GRIFFITH
Fall Fields (watercolor).
Courtesy of the artist.

The simplicity of metal frames will enhance most paintings.

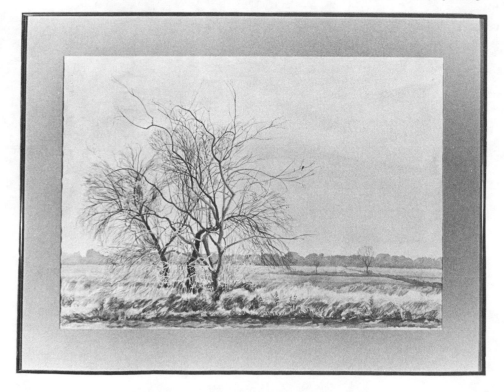

Painting on Unusual Surfaces

Traditional methods and materials are the result of centuries of experimentation and use, each artist choosing the medium best suited for personal expression. A contribution made by twentieth-century artists is that rigid barriers among media have been broken. Drawing, painting, three-dimensional forms, and even the performing arts may now coexist within the framework of a single art piece. As noted earlier, the most common manner of combining forms is called mixed media.

Once you have mastered some skills, you can experiment with any combination of materials. The basic limitation is avoiding the mixing of water and oil-soluble pigments.

Figure A.17
SCOTT HUDSON
The Creek (mixed media).
Courtesy of the student artist.

The water rhythms in this work were first applied to oatmeal paper with ink washes, then compressed charcoal, and finally the whites, done with typing white-out.

Figure A.18A
JASPAR JOHNS
Target with Four Faces (1955) (encaustic on newspaper over canvas surmounted
with four tinted plaster faces in a wooden box with a hinged front,
33⅜″ × 26″ × 3″).
Collection, The Museum of Modern Art, New York; gift of Mr. and Mrs. Robert C. Shull.

Encaustic, a painting medium using bee's wax as the vehicle for pigment, is
combined in this work to form what could be termed a "sculptured" painting.

121

Allow your personal interests to be reflected in the process. Marion Epting used the method of combining cardboard, silver paper, and Prismacolor pencils (available in sets of various sizes) to do a collage drawing dedicated to his daughter, Rahna. That Rahna

should have her "space" in the world was the motivating factor.

In the case of Jan Wagstaff, both a painter and weaver, the combining of the two media came naturally.

In my own case, the dual interest in

Figure A.18B
MARISOL
Women and Dog (1964) (fur, leather, plaster, synthetic polymer, and wood,
72" × 82" × 16").
Collection of Whitney Museum of American Art, New York.

Humor is an important ingredient in the three-dimensional painted works by Marisol.

Figure A.19
MARION EPTING
Rahna-Anhar (mixed media, collage and drawing).
Courtesy of the artist.

Part of the enchantment of mixed media is the unexpected changes in material
thicknesses, textures, and surface qualities.

123

painting and sculpture led me to work in life-sized papier mache, the surface of which is sprayed with acrylic.

Figures A.22–A.25 indicate ways you might explore unusual painting experiences.

A final thought—the more involved you become with painting, the more your uniqueness will show through. And remember, it is never too late to begin.

Figure A.20
JAN WAGSTAFF
Jessie (acrylic on woven canvas, 50″ × 55″).
Courtesy of the artist.

There is a fascination in Wagstaff's work in that it combines images from her world, as well as emphasizes relationships inherent in the form of weaving.

Figure A.21A

Figure A.21B (above)
Detail of *Beach Man*.
The shell and hands were as interesting a subject as the whole figure.

Figure A.21A
THOMAS GRIFFITH
Beach Man (life-sized acrylic papier-mâché).
Collection of Yvonne and John Anderson.

The wedding of color and three-dimensional form made papier-mâché a natural medium.

Figure A.22
PATRICIA LE FARE
Decorative Stump (gouache on wood).
Courtesy of the student artist.

Intriguing patterns give the wood forms an added dimension.

Figure A.23
KEN MORROW
The Fool (acrylic collage).
Courtesy of the artist.

By laminating various cloth or cardboard surfaces in acrylic medium on masonite prior to painting, low relief textures work as "counterpoint" to color.

126

Figure A.24
JOHN E. MAURER
The Visitor (oil on fired clay).
Courtesy of the artist.

The combining of various materials helps this artist achieve unusual and imaginative results.

Figure A.25
Acrylic paint can be used in lieu of glaze firing of clay in a kiln. Although not as durable as ceramic glazes, it is nevertheless waterproof as the heat melts it into the clay body. Paint the surface of a pre-fired (bisque) piece and place it in an oven set at 350°. When the paint becomes glossy, it has reached the melting point and may be removed from the heat.

Figure A.26
LANI SABATINO
From Bones (roofing tar on masonite).
Courtesy of the student artist.

Here is an inexpensive process that can serve as an introduction to oil painting: (1) Make preparatory drawings of your subject, thinking in terms of value and shape, working within predrawn borders. (2) Select a sheet of untempered masonite that is the same shape as your preparatory drawing. (3) Using various white and off-white papers, such as newsprint, paper toweling, or white bond, apply to the board with a broad brush and white glue thinned somewhat with water. These papers could be torn or cut to the sizes of your composition shapes. First apply glue to the board, then lay the paper down and add more glue to the surface. Work any air bubbles to the edges. These paper shapes may overlap; they do not have to fit together edge to edge. They are only roughly related to your composition in shape and value. (4) When dry, coat with several more layers of glue until the surface is quite smooth to the touch. (5) As in the case of oil paint, roofing tar is soluble in paint thinner, which is less expensive than turpentine. With brushes, rags, or paper toweling, you may apply the tar or remove it at will. The tar may be applied in thin washes or straight from the can. Lines or textures may be either brush work (for darks) or drawn with a Q-tip (for lights).

Figure A.27
ROY WETMORE
California Meadow (pastel).
Collection of Mr. and Mrs. D. Wetmore.

After many years as a professional printer, Wetmore discovered the fascination of
producing works of art.

Glossary

Abstract: A term referring to the process of modifying what has been observed for expressive purposes. *Abstract* is such a loosely applied word that it is used to describe works originating either in the imagination or the visual world.

Acetate: A lightweight plastic that may be used to protect the surface of works done on paper.

Alla Prima: A direct, simple application of pigment, as opposed to a carefully planned series of transparent paint layers; often associated with textured surfaces.

Atmospheric Light: Treating the picture plane as though it were a window through which to view distant vistas. Also called aerial perspective, it requires softened contrasts and color intensity as space increases between the spectator and portrayed objects.

Brushes: Of the various types, the following

are most practical: bristle for heavy pigment or broad washes, sable for thin pigment or watercolor, multimedia such as Erminette, and Oriental brushes capable of varying line widths.

Calligraphy: Line for line's sake alone. The flowing quality of Oriental brushwork is most readily identifiable as calligraphy.

Cast Shadow: The denial of luminosity that results when an object moves between the light source and a surface.

Collage: To glue or paste various materials to the picture surface, such as burlap, lace, sandpaper, or corduroy.

Color: That part of the total spectrum of energy wavelengths that is received by the eye. Aspects of color critical to the artist are as follows:
Hue: Identification of placement in the spectrum, such as blue.
Value: Darkness or lightness of hues (see Figure 5.4).
Intensity: Pureness or dullness of hues.
Analogous: Closely related hues, which when mixed, produce an intermediate range of equally intense hues.
Complementary: Hues that are unrelated, such as red and green. When placed adjacently they enhance their individuality, but when mixed will produce neutral colors.

Composition: To select and organize all the parts that make up a work of art. (See Elements of Art).

Contour: The outer edge of an object, frequently described by the artist with line.

Contrast: Areas of the painting that differ sharply, either in color, shape, or dark and light.

Counterpoint: Two separate statements coexisting in the same work, such as pen line and diluted ink brush wash.

Critique: A discussion of work either completed or in progress, with an eye toward making it as successful as possible.

Crosshatch: A series of drawn or painted intersecting lines that will result in an area of tone.

Design: The means whereby one conceives and executes a work of art.

Distortion: Not a derogatory term, it refers to the artist's modification of the visual world in order to intensify emotional content.

Dissonant: Jarring, angular, or sharply contrasting relationships may serve an expressive purpose in an art form.

Elements of Art: Guidelines for the methods used in creating an art form; line, form (volume), shape, texture, color, and space are primary in importance.

Energy: Wavelengths that manifest themselves in such ways as electricity, radio, X-ray, or the color and light so important to the artist.

Expressionist: A term to describe a strongly emotional or passionate response to life that is reflected in the artist's work. Expressionist paintings are largely intuitive rather than logically planned.

Eye Level: The line of vision that lies directly ahead while the viewer rotates 360 degrees; also called the horizon.

Figurative: The representation of living figures in drawing and painting.

Foreshortening: Perspective applied to irregularly shaped forms such as human anatomy.

Form: Another term for three-dimensional volume; and also the nature of the total work of art as determined by the chosen medium.

Geometric: Painting shapes relating closely to the square, circle, or triangle.

Gesture: Freely flowing line that captures a sense of life; and also a passage of closely related colors or values along which the eye may travel.

Glaze: Transparent washes through which the viewer may see earlier applications of color.

Graphic: The representation of lines, colors, and shapes on the two-dimensional surface.

Ground: The material, such as acrylic gesso, that coats the canvas or masonite support, and upon which the actual painting is done.

Harmony: Flowing, rhythmical shapes and related colors, as opposed to dissonant or harsh relationships.

Highlight: The area on an object that receives the greatest amount of light, usually obscuring local color because of strong reflection.

Image: That which is envisioned and represented in the form of a work of art.

Impasto: Thick application of pigment so that brush or palette knife treatment is in evidence.

Impressionist: Originally a critic's derogatory description based on Monet's *Impression, Sunrise,* the term later became identified with the nineteenth-century landscape group in which Monet was a central figure.

Intuitive: An approach to painting based on insight, feeling, and an accumulation of experience rather than logical planning.

Laminate: For artists, a process of enclosing thin or flat-shaped objects in a translucent film such as acrylic medium.

Lean to Fat: A term used to describe the oil painting process whereby layers of pigment increase linseed-oil content for greater durability.

Light Source: The point of origin of any light falling on objects. Knowledge of the light source is particularly useful when creating the illusion of three dimensionality on the picture plane.

Local Color: That color characteristic of an object, unaffected by reflected colors or highlights.

Mat: A cardboard inner frame, subsequently glassed and given a finished frame. Matted pieces are most frequently drawings or watercolors.

Matte: A flat, non-shiny painting surface.

Medium: The specific materials utilized to achieve the desired form of the artist; oil, watercolor, tempera, and acrylic are typical. Also, the dilutant used to thin pigment for easier applicaiton. Mediums may be oil or water based.

Neutral Color: Low intensity hues due to modification by addition of the complementary color. Neutral colors may be mixed in every hue range.

Nonobjective: Art imagery arising from imagined color and shape relationships rather than observations of the visual world.

Paint Quality: A sensuous quality when thick pigment is used with brush or palette knife, and a fluidity of feeling when using water-based pigments.

Palette: A surface upon which to mix paint; also, the artist's selection and arrangement of hues.

Perception: To gain knowledge of the world by means of the senses.

Perspective: *Linear*—a system for reduction of scale logically, predicated on the fact that there can be but a single point of view for each painting. *Aerial*—reduction of contrast and intensity as the illusion of space increases in distance.

Picture Plane: The actual working surface of a drawing or painting.

Pigment: A finely ground coloring agent that is mixed with a liquid vehicle to form paint.

Priming: The method of the masters was to first size (isolate) the canvas with an aqueous glue solution and then prepare the painting surface with white lead, called priming. Later developments with acrylic products have made the surfacing a single-step operation with a product called acrylic gesso.

Reflected Light: When light passes an object and strikes another surface, it will reflect to create a glow on the shadowed side of the volume.

Render: To depict with accuracy, as might be found in an architectural drawing.

Resist: A technique dependent upon the use of two media; one oil-based crayon or oil pastel, which will repel a second water-based medium such as watercolor or ink.

Rhythm: A visual "beat," involving the repetition of such visual elements as shapes, colors, or lines. Closely related is "theme and variation," which means that as elements are repeated there is greater interest if they are not identical.

Scale: Size relativity, sometimes referred to as proportion. For example, the scale of a miniature painting would look large if a vast landscape with spacious skies is the subject. A large painting of several oversized objects, on the other hand, may appear cramped, as though the picture plane were inadequate in scale.

Scrafitto: A linear and textural technique involving scratching through one layer of pigment to reveal what is beneath.

Scratchboard: Chalk-covered cardboard that will absorb watercolors or inks, which then may be incised with the scrafitto technique.

Scumble: To brush on pigment loosely, allowing for an interaction between upper and lower areas of color.

Silhouette: A flat, shadowlike image.

Sizing: Isolating canvas from the deteriorating effect of oil-based pigments by applying rabbit-skin glue or gelatine. Acrylic gesso eliminates the need for that procedure, but for those who want to use time-tested techniques, see the bibliography under Technical Information.

Social Commentary: Although many artists have dealt with an intuitive response to nature (as did Monet, for example), a characteristic of twentieth-century Mexican art has been a strong commitment to national issues (see Figure 2.25).

Solvent: Oil paint requires either paint thinner or turpentine as a dilutant; the other media discussed are water soluble.

Space: The illusion of deep space requires a knowledge of perspective; two-dimensional spatial relationships are the distances between areas on the picture plane.

Still Life: A motionless subject; literally anything that is motionless can be considered a subject for still life.

Stretcher Bars: Wooden strips used to construct a rigid frame upon which to anchor canvas for a painting surface.

Stretching Paper: After soaking watercolor paper in a tray of water and taping it to a drawing board, the drying process shrinks it to create a taut, nonbuckling painting surface.

Support: The backing or structural entity upon which the painting ground is applied.

Technique: Methods employed by the artist to make the best use of available materials to attain the maximum potential of a chosen medium.

Thumbnail Sketch: A preparatory drawing for determining the shape and character of the final composition.

Unity: A unified composition comes about through simplicity as well as a thoughtful consideration of the artist's intent.

Vanishing Points: The points where any set of receding parallel lines seem to merge in the distance. Regardless of how many parallel lines there are, they will appear to come together at exactly the same point.

Varnish: For oil painting, resins diluted in a solvent, which protects the pigment surface, as well as keeping color and value fresh. Acrylic varnish is water soluble, composed of the same substance in which the pigment is mixed.

Vehicle: The liquid in which pigment is ground to form paint.

Wash: A loosely applied area of diluted pigment, frequently composed of various colors. Washes are also an important factor in forming tones with brush and diluted ink.

Bibliography

Art Appreciation and History

ARNASON, H. H., *History of Modern Art.* Englewood Cliffs, N.J.: Prentice-Hall, Inc.; New York: Harry N. Abrams, Inc., 1977.

CANADAY, JOHN, *Mainstreams of Modern Art.* New York: Henry Holt, 1959.

CLEAVER, DALE, *Art, An Introduction.* New York: Harcourt Brace, 1977.

ELSEN, ALBERT E., *Purposes of Art.* New York: Holt, Rinehart and Winston, 1972.

HERBERT, ROBERT L., *Modern Artists on Art.* Englewood Cliffs, N.J.: Prentice-Hall, Inc., 1964.

HUNTER, SAM, and JOHN JACOBUS, *American Art of the 20th Century.* Englewood Cliffs, N.J.: Prentice-Hall, Inc.; New York: Harry N. Abrams, Inc., 1974.

JANSON, H. W., *History of Art.* Englewood Cliffs, N.J.: Prentice-Hall, Inc.; New York: Harry N. Abrams, Inc., 1970.

OCVIRK, BONE, STINSON, and WIGG. *Art Fun-*

damentals, Theory and Practice. Dubuque, Iowa: Wm. C. Brown, 1975.

PREBLE, DUANE, *Man Creates Art Creates Man.* San Francisco, Calif.: Canfield Press, 1973.

On Creativity

EISNER, ELLIOT W., *Think with Me about Creativity.* Dansville, N.Y.: F.A. Owen, 1964.

LOWENFELD, VIKTOR, and W. LAMBERT BRITTAIN, *Creative and Mental Growth.* New York: Macmillan, 1975.

Drawing and Painting

BRANDT, REX, *Watercolor Techniques and Methods.* Florence, Kentucky: Von Nostrand Reinhold, 1977.

————, Slide/cassettes and slides. Cranbury, N.J.: The Watercolor Workshop.

BRO, LU, *Drawing, A Studio Guide.* New York: Norton, 1978.

CHAET, BERNARD, *The Art of Drawing.* New York: Holt, Rinehart and Winston, 1978.

CHIEFFO, CLIFFORD, *The Contemporary Oil Painter's Handbook.* Englewood Cliffs, N.J.: Prentice-Hall, Inc., 1976.

CHOMICKY, YAR G., *Watercolor Painting.* Englewood Cliffs, N.J.: Prentice-Hall, Inc., 1968.

GOLDSTEIN, NATHAN, *Figure Drawing.* Englewood Cliffs, N.J.: Prentice-Hall, Inc., 1976.

HILL, EDWARD, *The Language of Drawing.* Englewood Cliffs, N.J.: Prentice-Hall, Inc., 1966.

LAUER, DAVID, *Design Basics.* New York: Holt, Rinehart and Winston, 1979.

MAYER, RALPH, *The Painter's Craft.* New York: Penguin, 1979.

NICOLAIDES, KIMON, *The Natural Way to Draw.* Boston: Houghton Mifflin, 1975.

SEARS, ELINOR L., *Pastel Painting Step by Step.* New York: Watson-Guptill, 1968.

SIMMONS, SEYMOUR, and MARC WINER, *Drawing, The Creative Process.* Englewood Cliffs, N.J.: Prentice-Hall, Inc., 1977.

TAUBES, FREDERICK, *Acrylic Painting for the Beginner.* New York: Watson-Guptill, 1971.

————, *Painting Methods and Techniques.* New York: Watson-Guptill, 1964.

VICKERY, ROBERT, *New Techniques in Egg Tempera.* New York: Watson-Guptill, 1973.

Color

ALBERS, JOSEF, *Interaction of Color.* New Haven, Conn.: Yale University Press, 1972.

BIRREN, FABER, *Principles of Color.* New York: Van Nostrand Reinhold, 1969.

FABRI, FRANK, *Color: A Complete Guide for Artists.* New York: Watson-Guptill, 1967.

ITTEN, JOHANNES, *The Art of Color.* New York: Van Nostrand Reinhold, 1974.

Technical Information

CHAET, BERNARD, *An Artist's Notebook, Techniques and Materials.* New York: Holt, Rinehart and Winston, 1979.

DOERNER, MAX, *The Materials of the Artist and their Use in Painting,* rev. ed. Eugene Neuhaus, trans. London: Hart-Davis, 1969.

LEVISON, HENRY W., *Artist's Pigments, Lightfastness Tests and Ratings.* Hallendale, Fla.: Colorlab, 1976.

MAYER, RALPH, *The Artist's Handbook of Materials and Techniques.* New York: Viking, 1970.

WOODY, RUSSELL, *Painting with Synthetic Media.* New York: Van Nostrand Reinhold, 1965.

Commercial Hints

BERLYE, MILTON K., *How to Sell Your Artwork.* Englewood Cliffs, N.J.: Prentice-Hall, Inc., 1978.

DONAHUE, BUD, *The Language of Layout.* Englewood Cliffs, N.J.: Prentice-Hall, Inc., 1978.

Art for the Handicapped

For free information on materials and media from the National Arts and Handicapped Information Service, write:

ARTS
Box 2040, Grand Central Station,
New York, N.Y. 10017

Art-Supply Sources

Although most art stores carry a broad range of equipment for the artist, catalog or group orders may be placed at several supply sources, often at a discount.

Andrews, Nelson and Whitehead (all types of art papers)
30-10 48th Ave., Long Island City, N.Y. 11101

ASF Sales (metal frames)
P.O. Box 6026, Toledo, Ohio 43614

Binney and Smith, Inc. (arts and crafts)
1100 Easton Lane, P.O. Box 431, Easton, Pa. 18042

Fezandie and Sperrle, Inc. (colors, stains, dyes)
111 Eighth Ave., New York, N.Y. 10011

Flax Artist Materials (all types)
4544 No. Central, Phoenix, Ariz. 85012
10852 Lindbrook Dr., Los Angeles, Calif. 90024
250 Sutter St., San Francisco, Calif. 94108
180 No. Wabash Ave., Chicago, Ill. 60601

Sam Flax, Inc. (all types)
1515 Spring St., Atlanta, Ga. 30327
555 Madison Ave., New York, N.Y. 10022
15 Park Row, New York, N.Y. 10038
25 E. 28th St., New York, N.Y. 10016
55 E. 55th St., New York, N.Y. 10022

Grand Central Artists' Materials, Inc. (all types)
18 E. 40th St., New York, N.Y. 10016

McMillan Arts and Crafts, Inc. (arts and crafts)
9645 Gerwig Lane, Columbia, Md. 21046

Pyramid Artists' Materials (all types)
P.O. Box 27, Urbana, Ill. 61801

Sax Arts and Crafts (arts and crafts)
P.O. Box 2002, Milwaukee, Wis. 53201

Triarco Arts and Crafts (arts and crafts)
1415 Fullerton Ave., Addison, Ill. 60101

Utrecht Linens, Inc. (all types)
324 Newbury St., Boston, Mass. 02115
111 Fourth Ave., New York, N.Y. 10003
657 Franklin Avenue., Garden City, L.I., N.Y. 11530
307 So. Broad St., Philadelphia, Pa. 19107

For those interested in obtaining reproductions or slides of artists' works, most museums have book stores where such items are available. For the most reliable information on high quality color slides, consult:

Slide Buyer's Guide, College Art Association
16 E. 52nd St., New York, N.Y. 10022
In addition to the guide, annual addenda are obtainable at a reasonable price.

Index